Dosso Dossi dip. G. Tubino dis. E. Fabbrini inc. n° St. Perfetti.

FATAL ATTRACTION

SEX AND AVARICE IN DOSSO DOSSI'S *JUPITER & SEMELE*

THE MATTHIESEN GALLERY

7/8, Mason's Yard, Duke Street St. James's,
London, SW1Y 6BU

Matthiesen Ltd.

7/8, Mason's Yard, Duke Street St. James's,
London, SW1Y 6BU
Tel: (+44) 20 7930 2437 Fax: (+44) 20 7930 1387

E-mail: Gallery@MatthiesenGallery.com
Web: www.MatthiesenGallery.com

AN INDEX OF INSTITUTIONAL CLIENTS
THAT HAVE MADE PURCHASES
FROM THE MATTHIESEN GALLERY

(MANY INSTITUTIONS HAVE MADE MULTIPLE PURCHASES)

AUSTRALIA
ADELAIDE — Art Gallery of South Australia
CANBERRA — Australian National Gallery
MELBOURNE — National Gallery of Victoria
SYDNEY — Art Gallery of New South Wales

CANADA
HAMILTON — McMaster University Museum of Art
MONTREAL — Montreal Museum of Fine Art
OTTAWA — National Gallery of Canada

DENMARK
COPENHAGEN — National Museum

FRANCE
AVIGNON — Musée du Petit Palais
BORDEAUX — Musée des Beaux-Arts
LILLE — Musée des Beaux-Arts
NANCY — Musée des Beaux-Arts
PARIS — Musée Carnavalet
Musée du Louvre
ROUEN — Musée des Beaux-Arts
TOULOUSE — Musée Fondation Bemberg
VERSAILLES — Musée et Domaine National

GERMANY
BERLIN — Gemäldegalerie, Staatliche Museen
KARLSRUHE — Staatliche Kunsthalle
MUNICH — Alte Pinakothek
STUTTGART — Staatsgalerie

ITALY
BOLOGNA — Pinacoteca Nazionale
FERRARA — Pinacoteca di Ferrara
Fondazoine Cassa di Risparmio
LUCCA — Banca del Monte
MANTUA — Banca Agricola Mantovana
MILAN — Civiche Raccolte d'Arte Castello Sforzesco
NAPLES — Banco di Napoli
Banca Popolare di Napoli
PISA — Cassa di Risparmio
CariPisa Fondazione - BLU
Palazzo d'Arte e Cultura
PESARO — Cassa di Risparmio
PRATO — Cassa di Risparmio
ROME — Banca Nazionale del Lavoro
SAN MINIATO — Cassa di Risparmio
SIENA — Monte dei Paschi
TURIN — Cassa di Risparmio

JAPAN
KOFU — Yamanashi Kenritsu Bijutsukan
KORIYAMA — Koriyama City Museum of Art
SHIZUOKA — Shizuoka Prefectural Museum of Art
TOKYO — National Museum of Western Art
The Tokyo Fuji Museum

NETHERLANDS
AMSTERDAM — Rijksmuseum
ROTTERDAM — Boymans von Beuningen Museum

POLAND
WARSAW　　　　　Royal Castle Museum

SPAIN
BARCELONA　　　Museo d'Arte de Catalunya
CASTELLON-
DE LA PLANA　　Museo de Bellas Artes
MADRID　　　　　Thyssen Bornemisza Collection

SWEDEN
STOCKHOLM　　　National Museum

SWITZERLAND
ZURICH　　　　　Kunsthaus Zurich

UNITED ARAB REPUBLICS
ABU DHABI　　　The Louvre Abu Dhabi

UNITED KINGDOM
BIRMINGHAM　　Museum and Art Gallery
CAMBRIDGE　　　Fitzwilliam Museum
CARDIFF　　　　National Gallery of Wales
EDINBURGH　　　National Gallery of Scotland
LONDON　　　　National Gallery
OXFORD　　　　Ashmolean Museum

UNITED STATES OF AMERICA
AMHERST　　　　Amherst College Art Museum
ANN ARBOR　　　Museum of Art, University of
　　　　　　　　Michigan
AUSTIN　　　　　Archer M. Huntingdon Art
　　　　　　　　Gallery
BALTIMORE　　　Walters Art Gallery
BIRMINGHAM　　Birmingham Museum of Art
BLOOMINGTON　Indiana University Museum
　　　　　　　　of Art
BOSTON　　　　　Boston Museum of Fine Arts
CHAPEL HILL　　Ackland Museum of Art
CHICAGO　　　　Art Institute of Chicago
CINCINNATI　　　Cincinnati Museum of Art
CLEVELAND　　　Cleveland Museum of Art
COLUMBUS　　　Columbus Museum of Art
DALLAS　　　　　Dallas Museum of Art

DETROIT　　　　　Detroit Museum of Art
FORT WORTH　　　Kimbell Art Museum
HARTFORD　　　　Wadsworth Athenaeum
HOUSTON　　　　　Museum of Fine Arts
INDIANAPOLIS　　　Indianapolis Art Museum
KANSAS CITY　　　Nelson-Atkins Museum of Art
LAWRENCE　　　　Spencer Museum of Art
LOS ANGELES　　　Los Angeles County Museum
　　　　　　　　　of Art
　　　　　　　　　J. Paul Getty Museum
LOUISVILLE　　　　J.B. Speed Museum
MEMPHIS　　　　　Memphis Brooks Museum
MILWAUKEE　　　　Milwaukee Art Museum
MINNEAPOLIS　　　Minneapolis Institute of Art
NEW HAVEN　　　　Yale University Art Gallery
NEW ORLEANS　　　New Orleans Museum of Art
NEW YORK　　　　Metropolitan Museum of Art
NORTHAMPTON　　Smith College Museum of Art
NOTRE DAME　　　Snite Museum of Art
OBERLIN　　　　　Allen Memorial Art Museum
OMAHA　　　　　　Joslyn Art Museum
PHILADELPHIA　　La Salle University Museum
　　　　　　　　　Philadelphia Museum of Art
PORTLAND　　　　Portland Art Museum
PRINCETON　　　　University Art Museum
RALEIGH　　　　　North Carolina Museum of Art
RICHMOND　　　　Virginia Museum of Art
SAN DIEGO　　　　San Diego Museum of Art
　　　　　　　　　Timken Art Gallery
SAN FRANCISCO　　M. H. de Young Memorial Art
　　　　　　　　　Museum
SARASOTA　　　　　Ringling Museum of Art
SOUTH HADLEY　　Mount Holyoke College Art
　　　　　　　　　Museum
STANFORD　　　　Iris & B. Gerald Cantor Center
　　　　　　　　　for Visual Arts at Stanford
　　　　　　　　　University
TOLEDO　　　　　Toledo Museum of Art
WASHINGTON　　　National Gallery of Art
　　　　　　　　　National Museum of Women
　　　　　　　　　in the Arts
WEST PALM BEACH　Norton Museum of Art
WILLIAMSTOWN　　Sterling and Francine Clark Art

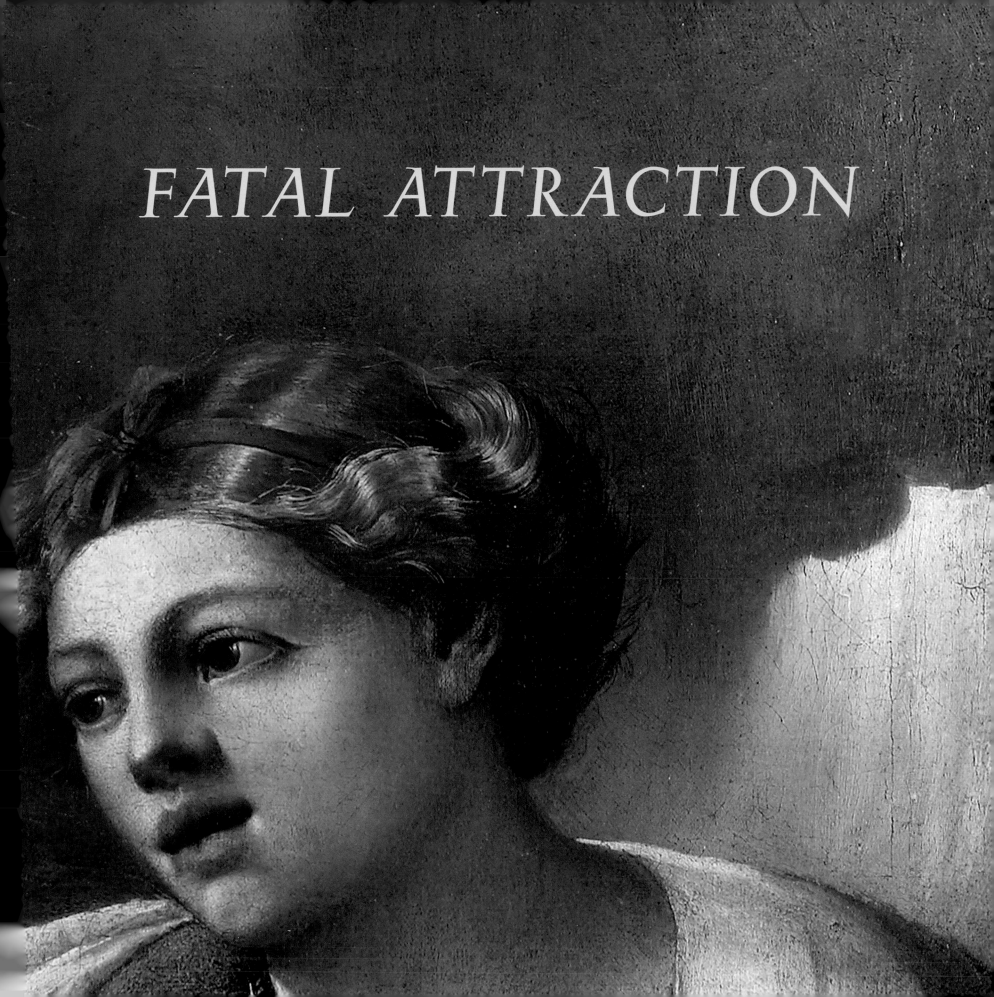

FATAL ATTRACTION

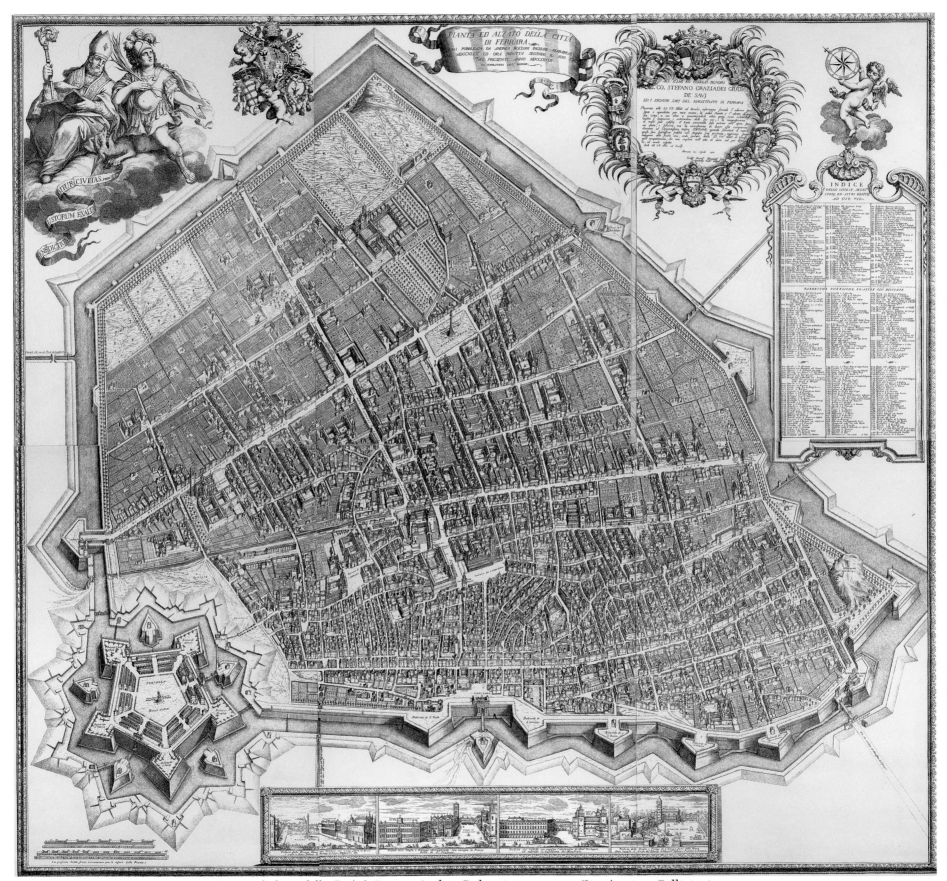

Pianta ed alzato della Città di Ferrara. Andrea Bolzoni, MDCCXLVII. Giambattista Galli, incisore.

INTRODUCTION

'La vita sa confondere le sue tracce, e tutto del passato, può diventare materia di sogno, argomento di leggenda.' (Giorgio Bassani)
'…the past counted far more than the present, remembering something far more than possessing it. Compared to memory,
every possession can only ever seem disappointing, banal, inadequate … (Giorgio Bassani)[1]

Fifty years ago, on the very day of the Spring Equinox falling on the twenty-first of March, I set sail from Alassio on the Ligurian coast to Corsica. My diminutive, vintage twenty-foot cutter, named *Margaret Catchpole* (**Fig. 1**), was designed in the 1930s for inshore navigation on the Thames Estuary.[2] Although the forecast had promised fair weather, by the time dusk fell that evening it had begun to deteriorate and later, by eight and in the dark, a howling gale had arisen; its bellowing blasts competed with the ominous broadcast of Wagner's *The Flying Dutchman* on the transistor radio below deck. As the night wore on, the shrieking winds increased to storm force totally blotting out the wailing chorus from below. Colossal foaming, breaking crests roared, pounded and shook us mercilessly, sweeping the boat and filling the cockpit. Finally, in the small hours, there was a thunderous sound followed by a glimpse of white spume as a rogue wave lifted, rolled and swept the yacht down its face on our beam ends before it, crushing the hull and splitting the coach roof from end to end. By morning, wet, half- drowned, chilled to the marrow and not a little terrified, our predicament was dire with a boat so full of water the hand pumps could no longer cope so that we had to resort to bailing by bucket; no food was possible bar the occasional swig of Glen Livet Scotch whisky for warmth and maybe also for courage. Our storm sails, torn into shreds, were streaming off the luff wire, the main was reefed to below

1. G. Bassani, *Il Giardino dei Finzi-Contini*, pt.III, chapter 3. All citations are from the Penguin Classics 1962 edition in English. '…for me, no less than for her, the past counted far more than the present, remembering something far more than possessing it. Compared to memory, every possession can only ever seem disappointing, banal, inadequate…She understood me so well! My anxiety that the present "immediately" turned into the past so that I could love it and dream about it at leisure was just like hers, was identical. It was "our" vice, this: to go forwards with our heads forever turned back.'

2. The boat, a Lynette class, designed by Eric Wigfull in 1936, was built by Johnson & Jago of Leigh on Sea, Essex. She slept three, was rather basic and had an open, non-draining cockpit. Despite not being a 'sea boat' she was extremely handy. Margaret Catchpole (1762-1819) was a Suffolk heroine who had the ill fortune to fall in love with a smuggler, William Laud, on whose behalf she was enticed into stealing a horse. For this she was subsequently deported to Australia; see Rev. Richard Cobbold (son of her former Suffolk employers) who made Catchpole the subject of a novel, *The History of Margaret Catchpole*, London, 1845.

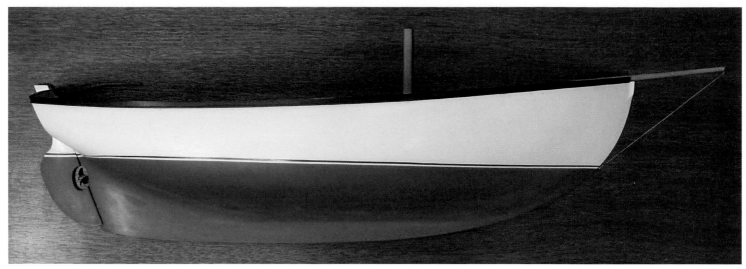

Fig. 1. The *Margaret Catchpole* (half model).

the cross-trees and so, unable to hold a steady course, we had been driven westward fifty miles, far out into the Golfe de Lyons. Having used our last distress flare the full story of how and why we found salvation, by a miracle and in consequence of both a wine tanker and two fishing boats foundering in our vicinity in the same storm, is too long to recount here, but the boat was seriously damaged, and this is probably the closest I have ever come to premature extinction (**Fig. 3**). [3]

༄ ༄ ༄

3. We found salvation by a 'miracle' owing to assistance given by the Adriatica Line motor ship *Esperia* which had been searching for survivors from the tanker (**Fig. 2**). No one had spotted our flares from the bridge. A chance waiter on the promenade deck reported to the captain and the ship's log states that the *Esperia* belatedly mistook us for a submarine, identifying the tip of our mast as a periscope! Possibly we owed our survival to sound seamanship as we had tried every known survival tactic in the manuals, from 'running before' towing heavy warps, to heaving to, to lying ahull; ultimately we were also assisted through the good offices of the auxiliary Bishop of Genoa, who, happening to be aboard, blessed the waters in an attempt to calm them by invoking the assistance of the Lord God Almighty. In this feat he was ably assisted by the *Esperia's* captain who pumped fuel oil onto the water. At the time that I clambered up scramble netting onto the deck of the liner the anemometer on the bridge was registering a steady 50 knots or 58mph (93 kph). The seas were twenty-five feet trough to crest. The Adriatica Line *Esperia* was built in 1949, 9314 tons. As built she accommodated 472 passengers. She enjoyed a long career and was finally scrapped in 1973. Four years later, in July 1968, I repaid my debt to the Almighty by initiating the rescue of four souls from a sinking motor yacht off Cape Finisterre in the English Channel during a force 7 blow.

Although at this time I was supposedly applying myself to the study of history, politics, philosophy and economics at Oxford there were other distractions too. When not errantly sailing an Alpha Class dinghy, close tacking up the Thames at night on the fickle zephyrs with my blonde law student girlfriend of the period, Alison, first to *The Perch* and then to *The Trout* at Godstow Lock for a welcome pint and a sandwich, I was watching nouvelle vague cinema. *Electra*, for instance, featuring Irene Papas, a particular heartthrob of mine at the time on account of her fine acting skills and Mediterranean mien (the young Eleonor Bron was another in the same mould). These nocturnal activities invariably resulted in a return after the Oriel College main gate was locked shut, necessitating a trip round the back to Magpie Lane so that one could scale the ten foot high stone wall to regain access to one's room. Yet I still managed to spend extensive periods either under a boat scraping and painting or at large in Italy. The curtailment of my equinoxial cruise that spring and the need to supervise repairs resulted in more time spent in Italy. During my teenage years I had acquired a close group of friends of my age in Liguria while hanging out in the wildly romantic surroundings of the Villino della Pergola (Villino Hanbury) where I had spent many holidays during my

Fig. 2. The M/V *Esperia*.

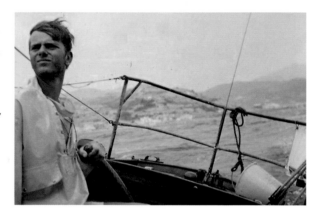

Fig. 3. The author, 1968.

formative years. We went walking, mountaineering, rock climbing, on fishing trips, sailing, of course, as well as on speleological expeditions. One of the latter entailed entering a cave accessed from the middle of a railway tunnel. This proved particularly exciting because one had to both carefully consult the train timetable, praying that this was the one day the trains actually did run on time, as well as place one's ear directly on the tracks in best Hollywood Western style in order to detect the warning of distant approaching vibrations. Though no Corycian stalactite cave,[4] once within the cavern, descending to various small lakes, still hoping to encounter a nymph

4. A cave on Mount Parnassus, sacred to Pan, as well as both a minor divinity and also the Corycian nymphs. It was named after one of them, Corycia, who became a mother to Apollo's son Lycorus. Apollo's worship in or near the cave, was verified by a number of inscriptions leading researchers to argue that both the original seat of Delphi worship and the myth of Delphi seem to have been established at Pytho and the Corycian Cave. See http://guideofgreece.com/corycian-cave.

sacred to Pan, the pressure wave caused by a train passing close overhead would 'fog' the air which would turn milky and opaque as the water droplets in the humid environment precipitated out. Yet not all my time was spent in dalliance. I had met the last Marchese del Carretto di Balestrino who resided in the remote but elegantly restored fifteenth century Genoese castle at Conscente.[5] We became friends and I regularly dined en tête-à-tête there with a ritual elegance which was reminiscent of the 1900s. On occasion we went to Monte Carlo in his vintage 1947 Silver Wraith Rolls Royce which had once belonged to an Indian maharajah. In the marchese's private chapel I discovered and published an unknown Guido Reni altarpiece, identified two unknown Lanfrancos and spent days researching the Costa archives in Albenga, which family was related by marriage to the del Carrettos.[6] Later attempts at early art dealing failed to purchase the Reni and a magnificent Magnasco, now in the Academia, Venice.

My Alassino friends, who were the offspring of the local mayor,[7] introduced me to Lelli, the daughter of a well-known local surgeon (**Fig. 4**). She was a year older than I, eminently more mature in her outlook on life than the gauche, callow youth that I then was. I had few immediate prospects at the time and thus her self-assurance, sparkling smile and her poise instantly totally conquered my all too susceptible heart. Adding to these virtues were striking Latin good looks and the fact that she was an accomplished piano teacher, whose forte was the impeccable execution of Scarlatti's melodious sonatas, played with breath-taking verve and brilliance. Needless to say I either sat at her feet in adoring worship listening, or shyly gazed at her 'doe eyed' on the beach from a

5. Luigi Rolandi Ricci was the last Marchese of a long line of del Carrettos who had dominated the Finalese, Balestrino, Millesimo and the valleys between Savona, Albenga and the sub Alps. He was a man of great distinction, charm and culture, an aristocrat from an earlier age who showed me great kindness. A Knight of Malta he was Grand Prior of Lombardy and the Veneto from 1969 until his death in 1977.

6. For a fuller account of this period and my researches which allowed me to be the first in 1966 to identify documents linking the Costas to several *Caravaggios* and other baroque paintings see *2001: An Art Odyssey*, The Matthiesen Gallery, London, 2001, pp. 21-29; for the Costa research pp. 27-29. See also Patrick Matthiesen and Stephen Pepper, 'Guido Reni: An early masterpiece discovered in Liguria,' *Apollo*, 100 (1970), pp. 452-462.

7. Their mother, Pina Balduzzi, adopted me as an additional 'son'. I would go down at Christmas to tend the *Catchpole*, sleep on her near freezing to death and be fed like a stray waif. Under her tutelage she taught me about *cotechino* with lentils (a New Year's Day dish), stuffed *totano* (squid filled with pine nuts, herbs, greens and garlic), the intricacies of *La Ventresca* (a stew made from the fatty stomach sack of tuna with olives and tomatoes and which, when cooking, smells like burning motor car tyres) and at Easter I would help make *Torta Pasquelina* (a Ligurian pie filled with green beet tops or spinach, artichoke, ricotta cheese and eggs. Made properly it is covered in 33 translucent layers of hand drawn puff pastry. The figure 33 relates to the age of Jesus Christ. You oil each layer with a feather before applying the next and I became a dab hand at this!)

discreet distance! From time to time we went on long walks in the hills through the chestnut groves where, like a latter-day nymph Karya,[8] she was instantly recognised as her father's daughter by every local *contadino* or *pastore*. It was an Arcadian idyll! These were the years of Gina Lollobrigida, Sophia Loren, Fellini's *Dolce Vita*, Monicelli and, above all, the great films of Michelangelo Antonioni often scripted by Giorgio Bassani; years embodying Style with a capital 'S' and Romance with a capital 'R'. These were also years in which my eccentricity, and relative poverty, were confirmed by my driving a 1936 Fiat 500 *Topolino* in which I slowly cruised across Europe each year at 30mph rather than in a dashing Alfa Romeo *Giuletta* drophead in the style of Mastroianni. It was in this vehicle that I consistently visited as many Romanesque churches as possible in the French countryside, a passion inherited from my mother. Few byroads were left unexplored. I was also totally immersed in '*la cultura Italiana*' at all possible levels. Nevertheless, one of the precepts that I lacked in these years, 1962-1965, was a working knowledge of Italian literature and so I asked Lelli to point me in the right direction. I subsequently, rather painstakingly, ground my way

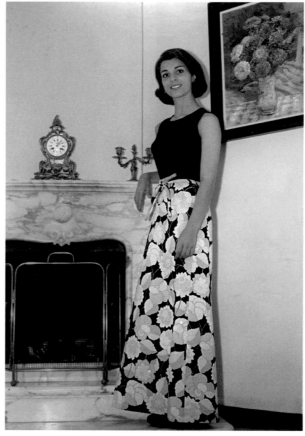

Fig. 4. *Lelli*, 1964.

through Manzoni's *I Promessi Sposi*, Macchiavelli's *The Prince*, Pirandello and Gabrielle d'Annunzio, thinking all the while how laborious the construction of Italian classic prose appeared to me when ranged against Stendhal, Balzac or Flaubert and, even more so, when matched against our own Dickens, Hardy or even Somerset Maugham.[9] Lelli did, however, introduce me in the intervals between the alternately soaring and cascading trilling scales of Scarlatti to four authors who left a mark: to Tommaso di Lampedusa whose *Il Gattopardo* was filmed by Visconti with the enchanting Claudia Cardinale at this very time; to Leonardo Sciascia, whose books I immensely enjoyed and of whom I am now reminded when watching the recent TV series *Il commissario Montalbano* which

8. Karya was a Dryad nymph associated with the sweet chestnut and other nut trees and was one of the eight Hamadryades.

9. My 'education' progressed through Carlo Cassola, Carlo Levi, Dacia Maraini, Cesare Pavese, Arturo Loria, Giovanni Arpino, Silvio d'Amico, Antonio Fogazzaro and Silvio Pellico for instance – all fashionable reads at the time but rarely did they rivet one's attention!

shares much of the self-same Sicilian flavour and good humour; to the essential Mediterranean essence of the poetry of Eugenio Montale whose first anthology, *Ossi di seppia* ("Cuttlefish Bones"), had appeared in 1925.[10] Lastly, she led me to the writing of Giorgio Bassani, who himself had been responsible, as editor at Feltrinelli, for publishing *Il Gattopardo*, which manuscript, quite astonishingly, had been rejected by both Mondadori and Einaudi. I had started with *Storie Ferrarese* with their interlinked characterisation – all Bassani's literature relates to Ferrara and the period just before or during World War II as the rise and fall of Fascism impacted on the local Jewish population.[11] From the *Storie* I progressed to *Il Giardino dei Finzi-Contini*, probably his masterpiece, now recognised as a classic, newly published in 1962 while later the subject of a film in 1970 directed by Vittorio de Sica. Here I became immersed in the pervading sense of foreboding, the lyrical, mist-shrouded trivia of daily life.

10. Montale may be Italy's greatest poet of the twentieth century. His essentially Ligurian poems, invoking the Mediterranean, greatly appealed to me with their sense of reclusion and solitude and with the distinct message that, in a world filled with anguish and despair, nature alone retains dignity. Verses relating to the Mediterranean Sea from these poems are cut into a stone and affixed to a wall overlooking the rock-strewn shore where I now habitually bathe at Cervo.
From *Ossi di sepia* I quote a poem that at that time was so relevant to my feelings:

'*Ripenso il tuo sorriso, ed è per me un'acqua limpida*
scorta per avventura tra le pietraie d'un greto,
esiguo specchio in cui guardi un'ellera e i suoi corimbi;
e su tutto l'abbraccio di un bianco cielo quieto.

Codesto è il mio ricordo; non saprei dire, o lontano,
se dal tuo volto si esprime libera un'anima ingenua,
vero tu sei dei raminghi che il male del mondo estenua
e recano il loro soffrire con sé come un talismano.

Ma questo posso dirti, che la tua pensata effigie
sommerge i crucci estrosi in un'ondata di calma,
e che il tuo aspetto s'insinua nella memoria grigia
schietto come la cima di una giovane palma...'

11. Ferrara in Renaissance times had been one of the first cities in Italy to allow Jews to live openly since 1227 as Jews, under the tolerant dukes of Este. As with the Medici family in Tuscany, the Estes welcomed Jews and secret Jews because of their ability to finance the rulers' vast building ambitions and wars. From the 1490s there was an influx of Spanish Jews and later in the sixteenth century some German Jews adding to the mix of synagogues mentioned in *Il Giardino dei Finzi-Contini*. The period of tolerance was to come to an end with the end of Este rule and a return to Papal control in 1598. The Jewish community of Ferrara is small today, about eighty members as opposed to several hundred before the Holocaust.

The tale of frustrated, unrequited romance with the all too familiar affliction of infelicity takes place in a provincial garden city which had yet to suffer the violations and the horrors of war, bombing by the Americans and subsequent redevelopment. The garden city was pillaged by these events which were to change its very nature '…those old trees, lindens, elms, plane trees, horse chestnuts which a dozen years later, in the frozen winter of Stalingrad, would be sacrificed for firewood, but which in 1929 still raised their giant umbrellas of greenery high above the city's ramparts.'[12] A sense of doom, menace and melancholy, so in tune with my own innate nature, was all-pervading throughout the Italian prose of this book.

It so happened that around this time I had gone to visit Ravenna, encouraged by my sagacious mother, intent on seeing the marvels of its mosaics. I was not to return there again until 2010, at which time, with a younger, perspicacious art-researcher travelling companion whom I hoped would be as enthralled as I had once been, I determined to see whether the 'magic' of those blue and gold tesserae that I had always so vividly remembered still held good. I was not disappointed and nor, I was gratified to detect, was she. From Ravenna I had in the '60s gone on to see the Abbey of Pomposa on foot, then, but alas no longer, lost among the foggy ditch-lined fields and remote from the tourist's eye; to Comacchio with its intimate simple *osterie* lining the canals and so onward to Ferrara. This part of the original trip I later retraced in 2010 and revelled in the vicarious pleasures of sensing and enjoying, through the younger and intellectually receptive eyes of my companion, the unalloyed sense of discovery of that which to her was new and entrancing, just as it once had been for me. The vitality of such an experience completely banishes any slight sensation of *déjà vu*. The original visit had later taken in Padua, Mantua, where I recall staying in the cheapest, most basic, class of hostelry, a *locanda,* costing 300 lire (about 20p or 30 cents a night). I proceeded as well to Cremona by some rickety local train where my memories of the gorgeous façade of the cathedral are, still now, crystallised by also remembering seeing an extremely beautiful auburn-haired Raphaelesque beauty, shrouded in a scarlet headscarf, praying in the nave. It is, indeed, curious how the mind can store a piece of trivia and link it to another event so that they are henceforth eternally recalled in tandem. From Cremona it was onward to Crema and the Certosa di Pavia. It was all far too brief, yet still had the power to strike a chord which echoed in Bassani's literature. As a result Ferrara lay like a seed awaiting germination implanted in the recesses of my mind.

12. G.Bassani, op.cit. *Il Giardino dei Finzi-Contini*, Part I, Chapter 5. The ramparts stretched for more than five kilometres starting from the end of Corso Ercole d'Este I and finishing at Porto San Benedetto by the railway station.

Fast forward some twenty years. The new gallery building at 7-8, Mason's Yard had been opened but a couple of years earlier and I found myself now in my guise of newly independent art dealer possessed of two Mazzolinos, a Lorenzo Costa, two Garofalos, an Ortolano, four Scarsellinos and no less than six works by Dosso Dossi. Among the Dossos there were three monumental figures of Learned Men of Antiquity or, as one was identified, St John on Patmos. This latter had been acquired from Arthur Rosner in Tel Aviv and its pendant had been sold in the early sixties to Alfred Bader, but the other two came to the gallery through a curious coincidence. While assembling the aforementioned treasure cache of Ferrarese art I was wont to visit a certain hotel which was conveniently located to access some gifted elderly frame-makers I then extensively used to embellish our larger baroque paintings. One evening, sitting in the lobby, I was consuming a welcome Negroni before indulging in dinner at a favourite watering hole. There I had promised myself excellent seasonal *insalata di ovoli* (the yellow autumn mushroom eaten raw as a salad) followed by home-made *tortellini* and, who knows, maybe even a *piatto di bollito misto* if the gastric system could sustain it all. Happening to look up, my gaze alighted on two large and filthy paintings hanging high above the level of the imposing palace doorways below the vaulted ceiling. To my astonishment I realised that these muscular 'Promethean' figures were by the same hand as our *St John* but recently acquired. I lost little time in starting negotiations with the owners and, within a year, had them at the restorer. After some research I discovered that all three had once been in the A.L. Nicholson Collection in Bournemouth, dispersed at Christies in 1927 and 1935.[13]

This purchase provided the final impetus for an exhibition of Ferrarese Art, then a somewhat neglected backwater in British art circles, but the favoured publishing theme of the great Roberto Longhi.[14] In this somewhat insanely ambitious project I was ably assisted by my 'right hand', the indomitable (and totally irreplaceable) Emily Farrow and by John Lishawa, then working for me. The breakthrough came when I was introduced to a local Ferrarese scholar working on a full, modern, annotated edition of Baruffaldi's *Indice*

13. I later sold all three large paintings to the late Barbara Johnson and subsequently resold the *St John* on her behalf to the Cassa di Risparmio di Ferrara, so, in fact, Dosso had come full circle home.

14. Roberto Longhi was perhaps the first art historian to dedicate serious analysis to this school of painting in *Officina Ferrarese*, Sansoni, Florence 1934 (reprinted 1956) immediately after a Renaissance Exhibition at Palazzo dei Diamanti. Bassani himself had hoped to study art history in Bologna under Longhi where he taught from 1934. 'The thesis I would have wanted to write under his supervision would have looked at a group of Ferrara painters in the second half of the fifteenth and the early sixteenth centuries: Scarsellino, Bastianino, Bastarolo, Bonone, Caletti, Calzolaretto and some others' (*Giardino dei Finzi-Contini*, pt. III, chapter 4) ironically the same painters I included in my 1984 exhibition. Yet Longhi at precisely this period went on two year's leave and Bassani instead dedicated his studies to literature.

Ragionato delle 'Vite de' Pittori e Scultori Ferraresi. His name was Emanuele Mattaliano.[15] I remember, as if it were yesterday, our first encounter on the platform of Ferrara's railway station. His mien and manner were such that at first I nicknamed him '*il piccolo professore*,' but thereafter his verve and bombast instantly melted any reserve I had initially harboured. Our passion for the project we were in the process of evolving ran like a toboggan on the Cresta Run – that is to say rather out of control: his enthusiasm was totally infectious, his anecdotes unremittingly hilarious. Through Emanuele's enterprise no stone in Ferrara was off limits, no object unattainable. Moreover, Emanuele had a good friend in Dottoressa Franca Lorusso, the Superintendent of the Modena museums who was able to open many doors, and also in an art historian, Amalia Mezzetti. I, in turn, through a friendship with Professor Carlo Volpe had access to a bevy of young Bolognese *studiosi*. Thus, in the astonishingly short space of less than nine months, the show was on the road with a total of ninety-four paintings, sculptures, objects and manuscripts, many being transported to London with an armed escort of *carabinieri*. It was a huge success as I have already recounted elsewhere. Needless to say, my pleasurable visits to Ferrara in the run up to the opening in 1984 were frequent and, with Emanuele as a guide, I got to know the city as well as her cuisine – *Cappellacci* filled with pumpkin (then a novelty, now even available in feeble imitation at Waitrose!), *Cappelletti ferraresi*, *La salamina da sugo* and, one of my favourites, *Cotechino*; *Risotto all'anatrita selvatica*, preferably shot on the marshes surrounding Ferrara, *Anguilla: detta la 'regina delle valli'* fished from the brackish streams and canals, and then the mouth-watering but girth-enhancing deserts: *Pampepato* and *Torta tenerina o 'tacolenta'*, both heavily based on fondant chocolate, or the less challenging but equally delicious *La persicata* made from caramelised peaches. All or each one was reason enough to return to Ferrara without even considering the added delights of the Pinacoteca or the Palazzo Schifanoia! What should be more natural, therefore, than once again to feel the potent sense of a 'trip down memory lane' that I touched on in the Introduction to the last catalogue, *Visions & Ecstasy*.[16] In truth one might quote from Dante citing *Era già l'ora che volge il disio*.[17] Thus when an unrecorded and unpublished Dosso Dossi *Semele* appeared, surfacing from Spain, the nostalgic urge to possess it and to relive a golden era was so strong that the final result, thanks to Beverly Brown's extensive and assiduous research, is that here we are publishing our forty-eighth catalogue.

15. I owe the introduction, as I owe so much, to Keith Christiansen. He had met Emanuele, who was then studying with a fellowship, at Columbia University.
16. *Visions & Ecstasy: G. B. Castiglione's St Francis*, London, The Matthiesen Gallery, 2013.
17. Roughly translatable as 'it was already the hour when longing returns,' Dante, *Purgatorio*, canto VIII.

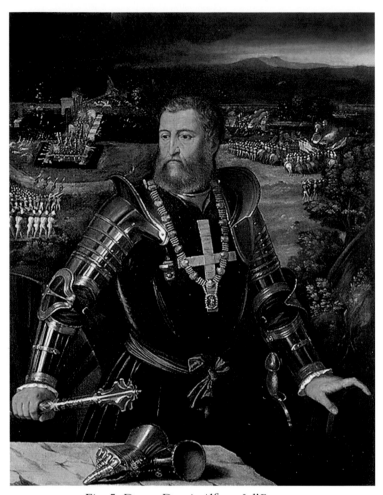

Fig. 5. Dosso Dossi, *Alfonso I d'Este*,
(Galleria e Museo Estense, Modena).

Dosso's *Semele* can be dated to the same period as the three large figures from our 1984 exhibition which the late Professor Federico Zeri had thought must be connected with the decorations for the castle at Trent, that is to say the mid- or late-1520s. The figures all share similar liquid brushwork, colouring and above all a clear debt to Michelangelesque musculature derived from the *Ignudi*. They were executed during the years when Alfonso I d'Este, who had married Lucrezia Borgia as his second wife in 1502, ruled Ferrara (**Fig. 5**). Ferrara had been and continued to be buffeted by the contrarian waves of power struggles unleashed by the plotting of the Sforzas with Cardinal della Rovere (later Pope Julius II) in a war-torn Italy invaded by Louis XII. In the early part of the sixteenth century the city, in part, had owed its survival and on-going independence to agile political footwork but it also had the added benefit of uniquely strong fortifications to dissuade aggressors; yet even these would not have withstood the politics and the newly developed military hardware of the French monarchy. The latter had devastated and sacked the walled city of Lucca in 1494 with newly cast bronze canon firing iron rather than stone shot. Florence had instantly capitulated and Pesaro, which was allied to Rome, also offered no resistance. It may have been for this reason that one of Alfonso's greatest passions was the casting of bronze canon. Of these 'among the more memorable, renowned throughout Europe, were the *Gran Diavolo* (Great Devil), which weighed over 14,000 pounds, the *Regina* (Queen), the *Terremoto* (Earthquake), the *Spazzacampagna* (Field-Sweeper), and the *Giulia*. This latter was cast in 1512 by melting down part of a Michelangelo bronze of Pope Julius II'.[18]

Both Alfonso's brother and half-brother had instantly plotted his overthrow in the first year of his reign,

18. E. Mattaliano, 'Women, Knights, Arms and Amours of the Estes of Ferrara in the Sixteenth Century', *From Borso to Cesare d'Este: The School of Ferrara 1450-1628*, The Matthiesen Gallery, London, 1984, p. 36.

resulting in their consequent imprisonment for 34 and 53 years respectively. Alfonso adopted a policy of nimble politics in order to retain independence, first joining the League of Cambrai against the threat of a territorially ambitious Venice and then joining Louis XII against the Pope. Later in 1526–1527 Alfonso participated in the expedition of Charles V, Holy Roman Emperor and King of Spain, against Pope Clement VII, and so in 1530 the Pope was forced once again to recognize him as possessor of the previously forfeited duchies of Modena and Reggio, but such recognition did not outlive the century.[19]

'Among his many hobbies, Alfonso cultivated one in particular (just like his brother Ippolito I, Cardinal d'Este): he was a great lover of art and collected major works. The Castle and various estates were enriched with stupendous masterpieces, and the *camerini* in particular were literally filled with them. Lombard sculptures and paintings by Titian, Giovanni Bellini and others were so jammed in together that there was no more space left between the doorways, windows and fireplaces. Even when in bed, the sight of a ceiling was made pleasing by the Dossi panels which decorated it. A large number of these paintings are bacchanals of men and women [or were scenes from mythology such as the *Semele*] …in wild abandon among a landscape background of groves and fresh water. Certainly both Alfonso and Lucrezia must have gazed upon them for a long time in order to excite fantasies or stimulate desires before returning to their chamber in the long, damp, foggy nights of the Ferrara winter'.[20] In 1529 Alfonso created the most magnificent gallery of his time, his *studiolo* or *camerino d'alabastro*, white marble-veneered walls under a gilded ceiling. The pale colouring of the marble led to this room being named 'the alabaster chamber'. Documents from Mario Equicola dated 9 October 1511 noted plans for decorating a room in Ferrara in which six fables (*fabule*) or histories (*istorie*) were to be placed. One of these was an *Aeneas and Achates on the Libyan* shore, painted by Dosso Dossi for Alfonso's *camerino d'alabastro* (National Gallery of Art, Washington). A letter from Alfonso, dated 14 November 1514, authorized payment to Giovanni Bellini for the first painting that was completed for the chamber. The elderly Giovanni Bellini had painted his masterpiece *The Feast of the Gods* in 1514, the last work he completed. With Bellini no longer available Alfonso turned to Titian. Over the next two decades Titian added three more paintings: *The Worship of Venus* (Museo del Prado, Madrid), *The Bacchanal of the Andrians* (Museo del Prado, Madrid), and *Bacchus and Ariadne* (National Gallery,

19. Alfonso secretly arranged for Charles V's general, the Templar Georg von Fundsberg, to have several of his novel top loading falconet canon which were used with devastating effect against the papal troops at the battle of Governolo in 1526 in an ambush. Giovanni di Giovanni de' Medici (1498-1526) also known as Giovanni delle Bande Nere, the papal commander, was fatally wounded by a poisoned ball.
20. E.Mattaliano, op.cit., 1984, p.36.

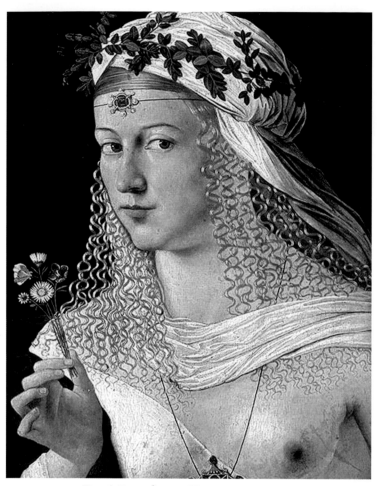

Fig. 6. Bartolomeo Veneto, *Lucrezia Borgia*, (Nimes, Musée de Beaux-Arts).

London). Dosso Dossi produced another large bacchanal and he also contributed ceiling decorations and a painted frieze for the cornice.[21] This latter decoration depicted scenes from the Aeneid which gained immediacy on account of its showing the heroes in contemporary dress. All the bacchanals in the Alabaster Chamber dealt with aspects of love; some refer to marriage. Meanwhile, by 1520, Dosso had begun incorporating Romanising elements into his art, including poses from Michelangelo and the ancient *Laocoön* sculpture.[22] After 1533 however, Battista, Dosso's younger brother, played an increasingly dominant role; he was to take over the workshop at Dosso's death in 1542.

Alfonso had also inherited from Cardinal d'Este the services of the poet Ariosto.[23] Following the lead of his father, Ercole, who had made Ferrara into one of the musical centres of Europe, Alfonso, but also Lucrezia, sought to bring many of the most famous musicians of the age to his court to work as composers, instrumentalists and singers. Musicians from northern Europe working at Ferrara during his reign included Antoine Brumel, Josquin des Prez, Jacob Obrecht and Adrian Willaert, the latter becoming the founder of the Venetian School of music, something which could not have happened without Alfonso's patronage.

21. Fragments from the Dosso Dossi frieze are scattered . A scene from the *Aeneid* was sold in New York, January 30th, 2014, Sotheby's lot 106. Three fragments are in private collections and others are in the Kress Collection (N.G. Washington), The Barber Institute, Birmingham and in Ottawa (N.G. of Canada).
22. Benvenuto Tisi, called Il Garofalo, had been invited to Rome in the years between 1509-12 by the Ferrarese nobleman Geronimo Sagrato. He worked there with Raphael on the Stanza della Segnatura. On his return to Ferrara he worked with Dosso on the Delizia di Belriguardo.
23. Ludovico Ariosto, 1474-1533, is best known as the author of the romance epic *Orlando Furioso* (1516). The poem, a continuation of Matteo Maria Boiardo's *Orlando Innamorato*, describes the adventures of Charlemagne, Orlando, and the Franks as they battle against the Saracens.

'Certainly Alfonso knew what he was about when it came to women. At his second wedding he married none other than the Pope's daughter. To tell the truth, both the newly-weds already knew their way around, this being his second time and her third. She had enjoyed a positively dreadful reputation due to her father's having repeatedly compelled her for political reasons, from the tender age of eleven onwards, to get engaged and subsequently break the engagement off. He forced her to marry first Giovanni Sforza of Pesaro (the marriage was later annulled with the false and reluctant admission of impotence on the part of the husband), and, subsequently, Alfonso of Aragon, later to be murdered by her brother Valentino. Valentino had already done away with a court servant unwise enough to have a love affair with his sister, the murder taking place before the Pope's very eyes and with blood being splashed on his face'. Lucrezia, in addition to bringing Alfonso a considerable dowry, was also a very beautiful woman with blonde hair as evidenced in her portraits (**Fig. 6**). A lock is preserved in the Biblioteca Ambrosiana in Milan. It was in honour of her hair that the people of Ferrara invented yellow *tagliatelle* (noodles), which even now are a culinary speciality of the city. Lucrezia, 39 years old in 1519, died of a haemorrhage at the end of a difficult pregnancy. Duke Alfonso was never to re-marry but this did not prevent him from siring in 1527 and 1530 two more sons, Alfonso and Alfonsino. It was precisely this Alfonsino, the son of Laura Dianta, who would later continue the Este dynasty in exile in the dominion of Modena.[24]

With Alfonso's death on October 31st 1534, shortly after the *Jupiter and Semele* was painted, the fortunes of Ferrara declined. He was succeeded by Ercole II d'Este. Through his mother, Ercole was a grandson of Pope Alexander VI, nephew of Cesare Borgia, and cousin of Saint Francis Borgia. Through his father, he was nephew of both Isabella d'Este and Cardinal Ippolito d'Este. He had married Renea, the daughter of Louis XII, invader of Italy and the King of France. Plain but cultured, she had studied philosophy, history, mathematics, astrology, and had debated religious matters. She filled Ferrara with French influence. Renea gave her husband five children. She would pass her time discussing theological issues and welcoming the many Protestants forced to flee from France and other parts of Europe. Even Calvin was briefly at the Court, under the name of Guiseppe d'Heppeville. Renea had her husband institute a Protestant chapel within the walls of the castle and engaged on what were considered anti-Catholic excesses thereby enraging the papacy so that in 1554 she was put under house arrest. That same year Ercole's house was burnt down. 'The Este Castle was partly burned and destroyed,

24. E. Mattaliano, op.cit., 1984, p.35.

Fig. 7. The *delizia at* Mesola.

and a number of *cameroni* (large rooms) and *camerini*, along with their furnishings, decorations and paintings, ended up in the ashes and rubble. Nevertheless, everything was soon reinstated, even larger and more beautiful than before.'[25] Five years later, Renea, following her husband's death, left Ferrara forever and retired to her castle in Montargis, France, a recognised hideaway for Huguenots.

🕊 🕊 🕊

Alfonso II's reign is a story of decline and disaster. On the night of the 17th November, 1571, there occurred the first of the not so infrequent earthquakes that afflict the region. An interminable series of tremors continued to be the scourge of the city for the following ten years. '…the shockwave was felt, strong to a degree that many chimneys fell, and many constructions were thrown into disorder.…The Duke and Duchess boarded a small boat in the castle moat and spent the night in a carriage.….at 3 a.m. there came a shock so horrendous that in comparison the others were nothing.'[26] The roof of the castle collapsed killing servants and porters. 'All of the old towers, including that of Rigobello, were ruined. The church domes crumbled to the terracotta floors. The arches of the chapels fell into the altars. Ostensoria and candlesticks were knocked over. Frightening cracks appeared in the walls. Stuccoes broke into pieces. House facades opened and fell onto the cobblestones, while ceiling plaster came crashing down onto beds and tables. The population slept among lime trees, cornice fragments and rubble in gardens for months.' Not a church was spared; from the marble decorations on the cathedral exterior to the Loggia dei Calzolai, the Palazzo della Ragione or St

25. E. Mattaliano, op.cit., 1984, p.37.

26. Antonio Frizzi, *Memorie per la storia di Ferrara*, Ferrara, 1791 and 1848, IV, pp.398-99. 'Alle ore 9 del di 17 Novembre se ne provò il primo scoppio, gagliardo a segno che caddero moltissimi cammini, e molte fabbriche si scompaginarono. Replicò poscia più volte in quell giorno e singolarmente con più forte impeto alle ore 20 e 24. Il Duca e la Duchessa allora entrati in una barchetta, per la fossa del Castello e de' giardini si trasferirono verso la Porta di S. Benedetto, ove passarono tutta la note dentro una carrozza…Quando alle ore 3 della notte seguì una scossa così orrenda, che al confronto riputaronsi nulla quant'altre si provaron pria o poi…'

Paul's, '…..what was left standing had to be propped up. All the streets were choked with rubble and the city took on a ghastly appearance.'[27] The Duke, by then fifty years old and disillusioned with life, had the last of the *delizie* built in the most isolated corner of the State of Ferrara, Mesola (**Fig. 7**). From here he would go hunting and mournfully look at the sea in a state of melancholic silence, walking the foggy dykes through the marshes, killing a deer should one start out of the undergrowth into a clearing. It was there that the final drama evolved of a man impotent before the injustices decreed by Fate. Fully aware that he was the last of his line he became cruel, so much so that killing a partridge on his reserve was grounds for being hanged in the square.

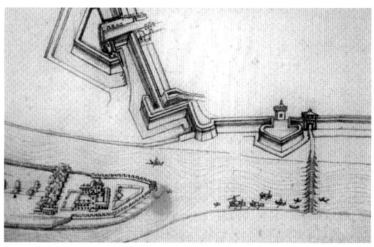

Fig. 8. Plan of the Belvedere Island *delizie*, detail from a map c.1578 (Archivio di Stato in Modena, Mappario Estense, Topografie di citta nr. 96).

'On the twenty-seventh of October, 1597, Alfonso died. Only two days later, Cesare, the would-be heir, in an attempt to circumvent the stipulation that prevented him (due to his illegitimate origins) from succeeding his cousin, had himself proclaimed Duke with a variety of *Te Deums* and popular feasting. The Pope, deaf to all reasoning, excommunicated him. Ferrara, he stipulated, had to return to the Church of Rome. Cesare gave in and on the twelfth of January, 1598, the so-called Convention of Faenza was drawn up to ratify the passing of the State of Ferrara into the hands of the Holy See. Cardinal Aldobrandini represented the Church and Alfonso's sister, Lucrezia, who had been sent by Cesare to represent the Estes, did too. In fact, she hated her cousin and accepted whatever was asked of her. What was worse, she fell in love with the Cardinal and made him heir to all her wealth, from her lands to her palaces, from her jewels to her paintings by Mazzolino. She, born the sister of one duke and subsequently the wife of another, grew old and bitter and finally left her consort in order to pass her final years hating everyone, beginning with her syphilitic husband, who preferred young girls.'[28]

The court left Ferrara and reinstalled itself in Modena[29] leaving many of the art treasures behind. The incoming

27. A. Frizzi, op.cit., 1791 and 1848, IV, pp.398-99.
28. E. Mattaliano, op.cit., 1984, p.37.
29. Much of what was transported to Modena was later lost to the Este dynasty either in settlement of debts to August III of Poland and the Elector of Saxony in 1746 (some of these works remain in the Gemäldegalerie, Dresden) or were looted by French troops in 1796.

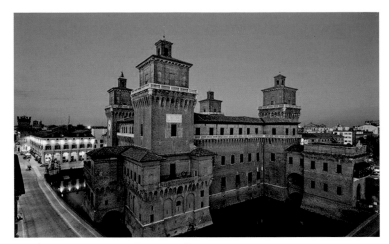

Fig. 9. The Castello Estense, Ferrara.

Fig. 10. Palazzo dei Diamanti, Ferrara.

cardinal legates took care later to dispose of the majority of these, including the decorated ceiling panels, thus expunging much of the Este heritage from the city. Not satisfied, they also plundered the churches and razed to the ground five of the principal ones along with notable palaces and the exquisite constructions on Belvedere Island (**Fig. 8**). The majority of the *delizie* were also destroyed along with their decorations and the materials reused to raise new churches and convents. Those that were not demolished fell into disrepair and oblivion. An entire quarter of the city was cleared to make way for a new fortress subsequently demolished in 1860 with Unification.[30] Ferrara's golden age, which had seen the flowering of a local school under Borso d'Este with such artists as Cosimo Tura, Francesco Cossa, Ercole de Roberti, Garofalo, Mazzolino, l'Ortolano, the brothers Dosso, Basterolo, Bastianino, Lo Scarsellino and Bononi, to name but the most celebrated, was at an end, its rich culture curtailed, mutilated, expunged.

It is hard to begin to imagine today what this city must have looked like before 1598 when at its cultural apogee surrounded by the many *delizie* or country lodges.[31] Ferrara remained as a part of the Papal States from 1598 until 1859, when it became part of the Kingdom of Italy. Yet much of the architecture which had resisted the devastating earthquakes survived. The Castello Estense (Castle of St. Michael) continues to this day to dominate the remnants of

30. For a fuller description of this debacle see Frizzi, op.cit., 1791 and E. Mattaliano. 'A Story of Cultural Disaster: the Dispersion and Destruction of the Artistic Heritage of Ferrara,' in *From Borso to Cesare d'Este: The School of Ferrara 1450-1628*, The Matthiesen Gallery, London, 1984, pp. 39-43.

31. The *delizie* were the Estense residences. There were once more than 30. Those still surviving are the castles or houses at Delizia Estense di Fossadalbero, Castello Estense della Mesola, Delizia Estense del Verginese, Delizia Estense della Diamantina, Delizia di Belriguardo, Delizia Estense di Benvignante, Villa della Mensa and Palazzo Schifanoia.

the mediaeval centre of the warren of streets criss-crossing the town (**Fig. 9**). This can be seen in the accompanying print of the city layout reproduced at the beginning of this introduction; the Palazzi dei Diamanti (**Fig.10**), Naselli Crispi Manfredi and Bentivoglio are redolent of the power and riches this city once exuded. Alas, many of the canals, including that traversing the very city centre in front of the Castello along the Corso Ercole I d'Este, were either filled in or covered over at the time of Mussolini's *bonifiche*. Yet still 'broad, straight as a sword from the Castello to the Mura degli Angeli, flanked its whole length by the sepia bulk of upper-class residences, with its distant, sublime backdrop of red bricks, green vegetation and sky, which really seems to lead you on towards the infinite: Corso Ercole I d'Este is so handsome. Such is its touristic renown, that the joint Socialist-Communist administration responsible to the Ferrara Council for more than fifteen years, has recognised the obligation to leave it be, to defend against every possible disruption or commercial interests…'.[32] The city, however, had the misfortune in WWII to be on the Axis' 'Gothic Line'. Strategic bombing by B-24 Liberators of the American Fifteenth Air Army on June 5 and again in August 1944, targeting the railway junctions and a Montedison synthetic rubber factory, flattened extensive areas of the renaissance city. Gardens were then later built over and the characteristic rustic cobbled streets asphalted; the city ramparts of Montagnone still extending for five kilometres in length were breached. It is harder today to imagine in one's mind's eye the rural-urban charm of certain Ferrarese quarters where immense gardens surrounded palatial residences, their estates in turn encircled by crumbling red brick boundary walls, where 'against the narcotic background choir of the cicadas, the odd isolated sound stood out sharply: a cock crowing, the noise of beaten cloth most likely made by a woman out late washing clothes in the khaki waters of the Panfilo canal….the ever-slowing ticking of the bike's back wheel, still in search of stasis.'[33]

For me then, the *Jupiter and Semele* embodies not just one but two echoes from a distant past in which I had experienced a heightened sensation of excitement and discovery while a yet unbeknown and unplumbed future beckoned. This was at a time when I sensed the excitement that pertains to both youth and romance; everything that was new was idealised, novel and had the ability to leave a potent mark – both by way of

32. So wrote Bassani in the *Giardino dei Finzi-Contini,* pt. I, chapter I in 1962, remembering pre-war Ferrara.
33. Bassani describes in the *Giardino* how Micol would climb up and down these walls using 'notches' in pt. I,Chapter 6. This too was rather reminiscent of my escapades scaling the wall at Oriel College. See also G.Bassani, op.cit. Il Giardino dei Finzi-Contini, pt.I, chapter 5.

experiences and emotions sustained. 'Compared to memory, every possession can only ever seem disappointing, banal, inadequate … *La vita sa confondere le sue tracce, e tutto del passato, può diventare materia di sogno, argomento di leggenda'*. The second resonance from a past now experienced at a remove of some thirty years from the original events recalls an epoch when my career as an art dealer was in the ascendant, when discoveries were multiple, thrilling, challenging and, dare one even confess it, risking the mundane, also remunerative. Furthermore, I find *Semele's* story particularly beguiling. She is, after all, human, young and more than fallible. I know from personal experience that unrequited, mordant and painful love,[34] as in the *Giardino dei Finzi-Contini*, is never fatal, yet a truly fatal attraction is quite another matter and, more often than not, ends in tragedy and self-destruction. It is a curious fact that the heart is a strong and resilient organ which soon shrugs off heartache and setbacks, yet when 'feelings' appeal to the very mind itself, rooting themselves in the subconscious assuming an attraction based also on the appeal of intelligence, then, indeed, it may become 'fatal'. Semele betrays that feminine failing of curiosity in her demands that Zeus (Jupiter), 'The Thunderer,' reveal to her his divinity, thereby sealing her fate to be incinerated by his thunderbolts. Zeus is almost universally portrayed in art as 'the older man' and none of the more recent restrictive conventions regarding any improprieties in associating with 'nymphs' then applied! After all, as the eternal *nulli secundus* on Olympus, age and wisdom were automatically perceived to be indivisible. The Romans were wholly sapient enough to devise a formula that would probably now be ruled as non-'PC'. This dictated that the ideal consort for a man was a woman half his age plus seven years! Maybe on account of of its sexual charge and innuendo, maybe because of its embodiment of human frailty, the *Semele* subjects proved popular in art well into the nineteenth century. Particularly popular in the sixteenth century, from Primaticcio to Tintoretto, and in the seventeenth as an excuse for eroticism, with Rubens, who could hardly pass up such a subject, there are examples by Nicolas Poussin, Johann Wilhelm Baur, Ferdinand Bol, Erasmus Quellinus, Pietro della Vecchia, Abraham Janssens and Paolo Pagani amongst others. The subject continued to be popular well into the eighteenth century with Deshays de Colleville, Jean Raoux, Francois Boucher and as a perfect subject for Sebastiano Ricci. However the most seminal image must surely be that of Gustave Moreau in the nineteenth century.

Finally, the very subject of *Semele* was the inspiration for so much good music, particularly baroque music to which I am somewhat addicted. *Semele* formed the basis for three operas of the same name; the first by John

34. See G. Bassani, op. cit., *Il Giardino dei Finzi-Contini*, pt. III, chapter 3 and ff., '…It was like a hand had grabbed hold of my stomach and twisted it.'

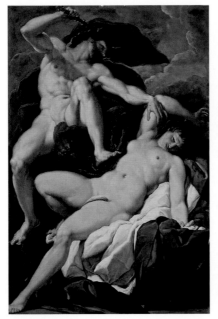

Paolo Pagani

Sebastiano Ricci

Abraham Janssens

Gustave Moreau

Eccles (1707, to a libretto by William Congreve), another by the great French composer Marin Marais (1709), and the third, indeed the most celebrated, by George Frederick Handel (HWV 58, 1742). Handel's opus, based once again on Congreve's libretto but with additions, while an opera to its marrow, was originally given as an oratorio so that it could be performed in a Lenten concert series; it premiered on February 10, 1744.[35] Eighteenth century audiences could not quite grasp Handel's score – not uplifting enough to be an oratorio in the mould of *Messiah*, yet not conventionally operatic enough with all its choruses and also not sung in Italian and thereby, by eighteenth century standards, 'unoperatic'! Contemporary audiences do not have this problem and I for one remember fondly the hilarious, romping and sassy production by English National Opera in 1999. The contemporary reviews, even at a distance of fifteen years, evoke a wry smile.[36]

I would imagine that many readers will have but glossed over the text of this Introduction, but to those few who persist in reading to the bitter end I offer this apologia for so much 'personal detail'. There are a few diehards who, each year, lobby me for more autobiographical detail, and this I try to dose as if through a pipette – but in essence, since I shall never write a full autobiography, I record this for the benefit of my twins, Alexandra and Takara-Julie in the hope that one day they may find amusement recalling such anecdotes about their father. The fundamental flaw in my inherently melancholic nature inclines to the past rather than to the present or future; that is to say I share a characteristic with the protagonists in *Il Giardino dei Finzi Contini*. There they state that they 'go forwards with our heads forever turned back'.[37] The past can appear so much safer, so much more welcoming. As the sands of time slide inexorably through the clessidra so, from the vantage point of age, all that is past and has been experienced also has a tendency to be viewed through rose-tinted spectacles – the pain and anguish has dissolved and only the good is remembered vividly and with affection. It is as if the present,

35. Winton Dean, *Handel's dramatic oratorios and masques*, London: Oxford University Press, 1959, p. 365.

36. 'Rosemary Joshua sang it with terrific charm and abandonment in Robert Carsen's handsome staging (first seen at the Aix-en-Provence Festival in 1996). Her embellishments seemed to proliferate in direct accordance with her dizzying conceit. Glitter and be gay, gayer, gayest. But is that all there is to Semele? Good-time girl with delusions of immortality sees the error of her foolish ways and is reborn in the form of Bacchus, god of wine, to bring untold pleasure to all? Well, yes, that is about it. And yet we are charmed and touched by her plight. In a sense, we participate in her dreams, refusing to accept, as she does, that she is but a plaything of the gods,' Edward Seckerson in *The Independent,* 21 April 1999.

37. G. Bassani, op.cit. *Il Giardino dei Finzi-Contini*, pt.III, chapter 3.

with its ups and downs, stresses and strains and its banal, inevitable load of problems is comparable to a movie viewed in black and white. The past, in contrast, is always in glorious Technicolor, quite the opposite to what one might think!

ꝣ ꝣ ꝣ

I am much indebted to Beverly Brown for her extensively researched essay publishing new material on the iconography of *Semele*; to Ian Jones of the Warburg Institute for his assistance with imaging; to Clare Wadsworth for proofing and chastising me for missing commas and hyphens; to Giacomo Algranti; to Tessa Castellano; to Capucine Montanari for framing; to Lynn Roberts for advice on the frame description; to Umberto and Stefano Ticci and lastly to Renzo Parini, Ilio Menicali and Roberto Cesaro for helping me bring to realisation yet another printed book along the demanding lines that my follies dictate.

PATRICK MATTHIESEN
MARCH 2014

GIOVANNI DI NICCOLÒ DE LUTERI
called DOSSO DOSSI

(1486? - 1542)

Jupiter and Semele

Oil on canvas
69 x 50 in (177.2 x 127.5 cm)

Framed in a seventeenth century frame circa 1600.

PROVENANCE:
Duke Alfonso I d'Este, Castello di San Michele, Ferrara circa 1524-1527?
Thence by descent to his son, Ercole II d'Este (1508-1559);
By descent to his son, Alfonso II d'Este (1533-1597);
Private Collection, Spain.

For an artist who had dominated his local school in the sixteenth century, serving two dukes of Este, little original work by Dosso now survives *in situ* in Ferrara, with the exception of the Costabili polyptych. Dosso, who except perhaps for a brief early period, spent his entire career serving the court in Ferrara producing ephemera for courtly activities such as pageantry decorations, banners, flags and theatre decoration as well as embellishments for the many stately palaces and *delizie*, frescos, portraits and paintings. With the ending of Este rule and the return of the city to the papal control in 1598 much of Dosso's output, the work of three decades, was either removed, sold or simply destroyed.

Dosso's father, Niccolò, was born in Trent but by the end of the fifteenth century was living in Tramuschio in the city-state of Mirandola close to both Ferrara and Mirandola. A document of July 1513 places Dosso in Ferrara where he is referred to as 'Dosso di Mirandola'. The nickname 'Dosso' appears to have originated from the family's ownership of a small estate in Dosso, within Manuan territory, close to Tramuschio. A recently discovered legal document of 1512 implies that the artist was then 25 and that therefore his birthdate should be around 1486-7. His earliest recorded work, now presumed lost, is datable to 1512 and was 'a large picture with eleven figures' destined for the Palace of San Sebastiano in Mantua for Alfonso d'Este's brother-in-law, Francesco II Gonzaga. Vasari had recorded that Dosso's first master was Francesco Costa, court painter to Ferrara from 1506/7, but his style shares little or nothing with this artist. By 1513, together with Benvenuto da Garofalo, Dosso is recorded as receiving an initial payment for the Costabili altarpiece. A putative early trip to Rome at about this time has little secure evidence and it may well be that

any 'Romanising' influences received were by means of prints and more directly though Garofalo and Dosso's brother, Battista, who definitely did visit the city. Direct knowledge of Raphael was certainly through two cartoons, the one for a fresco in the Stanza dell' Incendio and the other for a painting of St Michael sent to the king of France – the cartoons arrived as a gift to Alfonso I in 1517 and 18. Rather the artist closely favoured Venetian tendencies visiting the lagoonal city on several occasions between 1516-19 and travelling with Titian to Mantua in 1519 as well as also visiting Florence in 1517.

Ferrara was not devoid of artistic cross currents at this time: major painters such as Fra Bartolomeo (1517), Michelangelo (1529) and Titian visited the court, the latter repeatedly for his commissions for the *Camerino*. Since the town was also a crossroads for traffic from northern Europe across the Brenner Dosso would have been exposed to Flemish painting and of course the prints of Altdorfer and Durer. When not working for Alfonso between 1512 and 1527 Dosso was engaged on three major altarpieces for Modena, a city nominally under Este control, or 1531-32 was engaged on ceilings and friezes decorating the palace of the cardinal-archbishop of Trent, Bernardo Cles. In 1530 Dosso was invited by Eleonora, duchess of Urbino, to decorate the Villa Imperiale outside Pesaro where, with Battista, he painted the Sala delle Cariatadi and may have participated with the young Bronzino and Raffaellino del Colle in further rooms. After Alfonso's death in 1534 Dosso continued to work for Ercole II decorating the *delizie* of Belriguardo and Belvedere in 1536.

Yet Dosso's favourite subjects, where he shows his most painterly invention, were always mythologies some of which are based on subjects derived from Ariosto such as the *Melissa* (Rome, Galleria Borghese). Others include the *Seven Allegorical Rhomboids* (variously in Modena, Galleria Estense; Venice Fondazione Cini; Eger, Dobò István Vármúzeum); *Allegory of Pan* (Los Angeles, J.Paul Getty Museum); *The Transformation of Syrinx* (Rome, Galleria Borghese); *Allegory of Fortune* (Los Angeles, J.Paul Getty Museum) and *Allegory of Hercules* (Florence, Galleria degli Uffizi). Many, like the *Jupiter and Semele* published here, contained complex allegories, double meanings or intellectual conundrums.

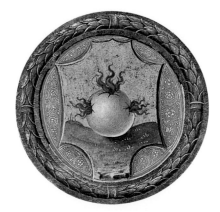

The emblem of the '*granata svampante*' of Alfonso I d'Este. Detail from Matteo da Milano, *Breviary of Ercole I d'Este*, c. 1505. Biblioteca Estense Universitaria, Lat. 424=Ms. V. G. 11, fol. 329v.

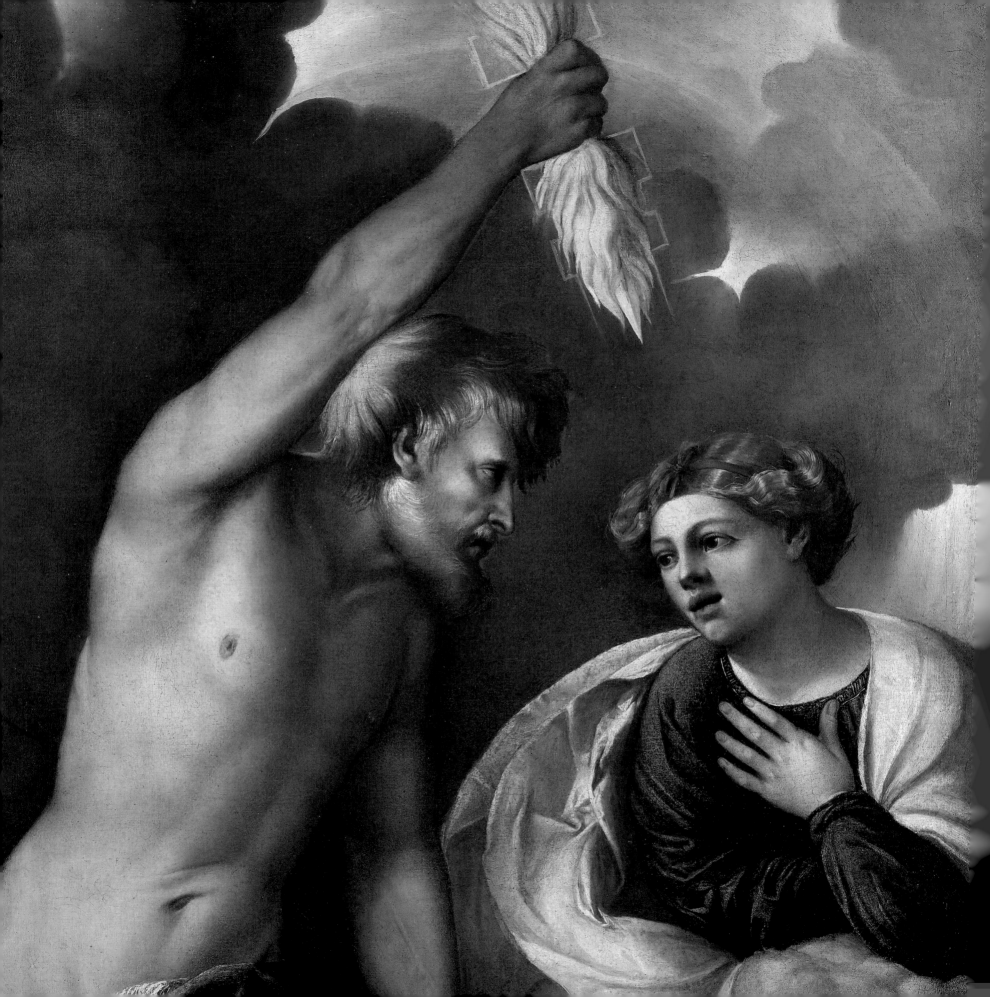

FATAL ATTRACTION:

SEX AND AVARICE IN DOSSO DOSSI'S *JUPITER AND SEMELE*

Every time Usain Bolt sails across the finish line, scorching the track and leaving records and rivals in his wake, he strikes the pose of 'Jupiter Fulminator' hurling a thunderbolt from the heavens (**Fig. 1**). Bolt's celebratory stance, beamed around the world in seconds, is based on well-known images of the supreme Greco-Roman god, who was known as Zeus to the Greeks and Jove (Jupiter) to the Romans (**Fig. 2**).[1] From the time of Homer, Jupiter was depicted in sculpture as well as on coins and pottery as a mature bearded man with a powerful body. Although Bolt lacks Jupiter's beard, his pose exudes the omnipotent prowess associated with the god. During the Renaissance Jupiter's prowess was associated not with sport but with the art of ruling.[2] Federico da Montefeltro, Federico Gonzaga, Alfonso I d'Este, Charles V and Philip II all at one time or another associated themselves with Jupiter and good governance.[3] A late fifteenth-century epic poem by Tito Vespasiano Strozzi, entitled the *Borsiad*, recounts how Jupiter personally arranged for Borso d'Este (1413-1471) to rule Ferrara despite his illegitimacy. Indeed the adulterous affair that resulted in his birth was celebrated as an act of divine providence. Jupiter proclaimed that Borso was 'to be born the way that deities are born,

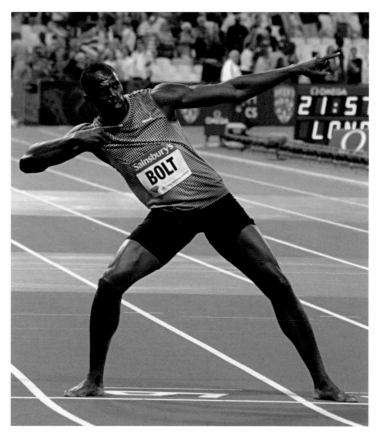

Fig. 1. Usain Bolt as "Jupiter Fulminator".

owing nothing to any bonds or laws of human marriage'.[4] Borso's nephew, Alfonso I (1476-1534), too seems to have intentionally aligned himself with Jupiter, adopting a version of the god's thunderbolt as one of his *imprese* or personal devices. Alfonso's *granata svampante*

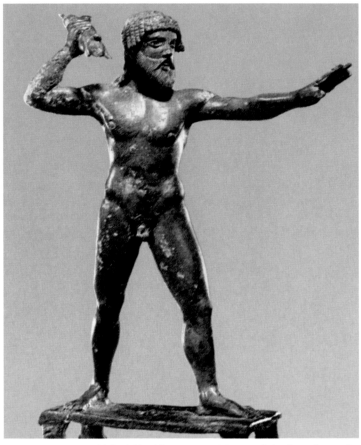

Fig. 2. *Jupiter*, c. 470-460 BC. Bronze. National Archaeological Museum, Athens, inv. no. 16546.

Fig. 3. *Granata svampante*, detail from Matteo da Milano, *Breviary of Ercole I d'Este*, c. 1505. Biblioteca Estense Universitaria, Lat. 424=Ms. V. G. 11, fol. 329v.

Loggia degli Aranci of the Castello in Ferrara as well as in the lavishly illustrated Breviary and the Book of Hours by Matteo da Milano (**Fig. 3**).[7] Paolo Giovio was later to associate the *granata svampante* with Alfonso's victory over the papal and Spanish troops during the battle of Ravenna in 1512. He describes how Alfonso carried a smouldering metal ball filled with artificial fire into battle.[8] Like Jupiter with his thunderbolt, Alfonso was able to unleash the power of his fiery ball with remarkable precision and devastating consequences.

Given Alfonso's fondness for Jovian imagery, it seems likely that a recently discovered painting by Dosso Dossi (1486?-1542) of Jupiter brandishing a thunderbolt (**Fig. 4**) was one of works he commissioned in the 1520s for either the Castello or his Belvedere retreat.[9] Stretched diagonally across the canvas, Jupiter ominously holds his thunderbolt precariously close to the head of a frightened girl. Dark storm clouds gather in the sky blotting out the last rays of golden light while a swirling cloak of smoke begins to encircle the endangered girl, completely concealing her lower

is a flaming grenade or cannonball depicted hurtling through space. In a poem first published around 1530, Scipione Balbo da Finale describes how Alfonso had 'golden globes resplendent with three flames' placed along the roofline of the Belvedere, a villa and garden located on an island in the river Po just outside Ferrara.[5] He goes on to remark that the brilliance of the globes pleased even the father of light, that is to say Jupiter himself.[6] Alfonso's device is also found on the bottom of the pilasters in San Cristoforo alla Certosa and in the

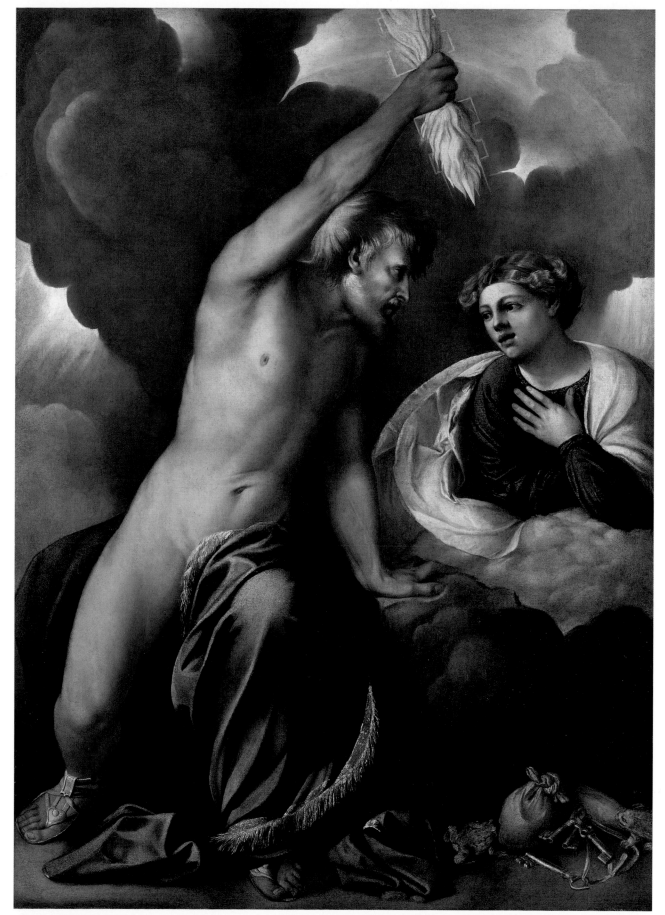

Fig. 4. Dosso Dossi, *Jupiter and Semele*, c. 1524. Oil on canvas. The Matthiesen Gallery, London.

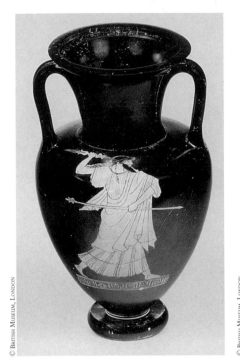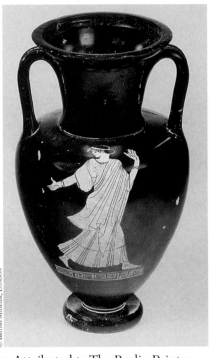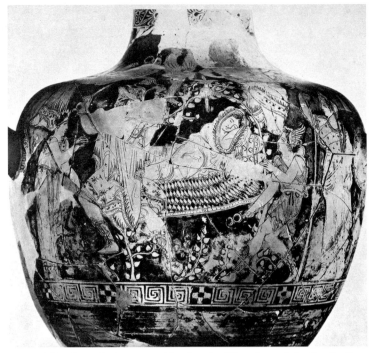

Fig. 5 A/B. Recto and verso. Attributed to The Berlin Painter, *Jupiter in Pursuit of Semele*, 480-470 BC. Red-figure Amphora from Nola. The British Museum, London, inv. no. E313.

Fig. 6. The Semele Painter, *The Death of Semele and the Birth of Bacchus*, late 5th century BC, Red-figure Hydria, Phoebe A. Hearst Museum of Anthropology, Berkeley, inv. no. 8-3316.

body. She is presumably Semele, one of Jupiter's mortal dalliances, who was reduced to ashes in a blistering moment of sizzling passion. The story of Jupiter and Semele is best known from Ovid's *Metamorphoses* (3. 253-315), which recount how Semele was loved by Jupiter because of her beauty. When word of her pregnancy reached Jupiter's wife Juno (Hera in Greek), the angry goddess disguised herself as Semele's old nurse Beroë. Beroë persuaded Semele that the only way to be certain that her lover was who he claimed to be was to ask him to make love to her in all his divine splendour just as he did with Juno. Semele was doomed by her request. When Jupiter appeared in full majesty

accompanied by thunder and lightning, she was unable to endure the onrush of heavenly power and was consumed by flames as they made love. Jupiter then pulled the unborn Bacchus (Dionysus in Greek) from her womb and sewed him into his thigh to await his proper birth. Dosso's representation of the myth is not straightforward. There is little indication of the narrative content and he has laid a curious selection of objects at Semele's feet: rocks, a moneybag, two toads and a number of scattered keys. None of these objects appears in any of the contemporary or classical versions of the myth. Rather they are standard emblems associated with the deadly sin of avarice. Dosso's mosaic

of seemingly unrelated motifs may appear perplexing. His combination of classical mythology and Christian morality was intended to stimulate a debate whose outcome might reveal some of human nature's hidden aspects. He sets forth a courtly game in which the viewer is invited to unravel the puzzle. Yet in order to do so one must first understand the literary and visual traditions Dosso drew upon when creating his unique image of sex and avarice.

THE TALE OF JUPITER AND SEMELE

In antiquity Jupiter's aggressive prowess was matched by tales of his insatiable sexual appetite. Despite his marriage to Juno he was incapable of restraining himself, with the result that his lovers frequently had to face the wrath of his outraged wife. Although Semele is not the best-known of his many dalliances she is the one who paid the greatest price for her ardour. She is mentioned by Homer in the *Illiad* (14.325) as the mother of Bacchus and appears in a Homeric Hymn.[10] Hesiod also briefly comments in the *Theogony* (940-2) that she bore Jupiter an immortal son. The fuller version of her story, which perhaps had its origins in a lost play by Aeschylus, had become a standard part of the repertoire by the first half of the fifth century. Diodorus Siculus (4.2.2-3), Apollodorus in *The Library* (3.4.1-3), Ovid and later Hyginus in the *Fabulae* (167, 179), all tell how when Semele was pregnant with Jupiter's child a jealous Juno raised doubts in her mind about her lover's

divinity, which ultimately led to her incineratory death. While the literary tradition of Jupiter and Semele appears to have been well established, visual representations of the tale were infrequent. Only a handful of Attic red-figure vases depict Jupiter in pursuit of Semele. On one side of an amphora attributed to the Berlin Painter, Jupiter is seen striding forward with the intent of destroying his victim. Flames stream from his thunderbolt, while on the other side of the vase a terrified woman flees (**Fig. 5**). The figures are not labelled, but the urgency of the woman's movement and her imploring gesture strongly suggest that she is Semele.[11] In a scene of greater complexity, on a red-figure hydria, there can be no doubt that the recumbent figure is Semele (**Fig. 6**). As Jupiter's formidable thunderbolt erupts in a display of pyrotechnical brilliance above her bed, the young Bacchus is pulled from her womb.[12]

Other stories sprang up around Semele as well. Both Diodorus (4.25.4) and Apollodorus (3.5.3) report that Bacchus went down into Hades and brought his mother up from the dead. She is renamed Thyone and ascends to heaven with the other gods. In *Imagines* (1.14) Philostratus the Elder describes how the figure of Semele is dimly seen against the fire as she ascends to heaven, while the radiantly shining young Bacchus makes the flames look dim. Nonnus of Panopolis in *Dionysiaca* (7.145-55) shifted the emphasis of the story completely to Bacchus and the production of wine. He recounts how Semele dreamt of a tree with unripe fruit. When the tree was struck by lightning the fruit was miraculously saved. But none of these

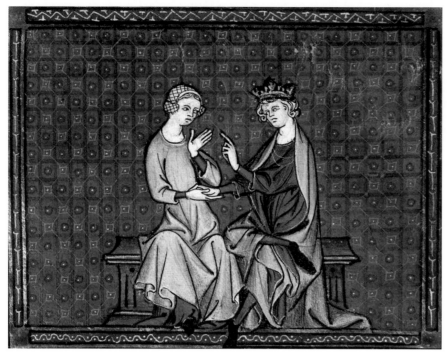

Fig. 7. *Semele and Jupiter* from *Ovide Moralisé*, ca. 1313. Rouen Bibliothèque municipale, MS 0.4, fol. 76v.

Fig. 7a. *Semele and Jupiter*, Rouen Bibliothèque municipale, MS 0.4, fol. 76v.

episodes seem to have been depicted in the visual arts.

Like Hyginus, the Latin mythographers retold the classical legends in a summary fashion. However, they also imposed allegorical interpretations on them that made the stories of pagan lovemaking more palatable to Christian readers. In the fifth century Fulgentius described in *Mitologiae* (2.12) how the four daughters of Cadmus represent the four stages of intoxication.[13] Ino was the excess of wine, Autunoë was the forgetful state bought on by drink, Semele, the mother of Bacchus, was intoxication born of lust and Agave was comparable to insanity because in her drunken state she cut off the head of her son. This interpretation is repeated by the first and second Vatican mythographers as well as others.[14] An anonymous sixth-century writer, known as the Pseudo-Nonnus, provided commentaries to clarify the pagan references in four of Gregory of Nazianzus's homilies. He explained in the homily for Epiphany that 'a thigh in travail' referrers to Jupiter's 'pregnancy' with Bacchus.[15] The persistent survival of Greek mythology in the Christianised world is epitomised by *Ovide moralisé*, a French paraphrase of the *Metamorphoses* written at the beginning of the fourteenth century by a Franciscan friar. Sexuality and transgression are intertwined with Christian teachings in an attempt to make Jupiter's lustful transformations

40

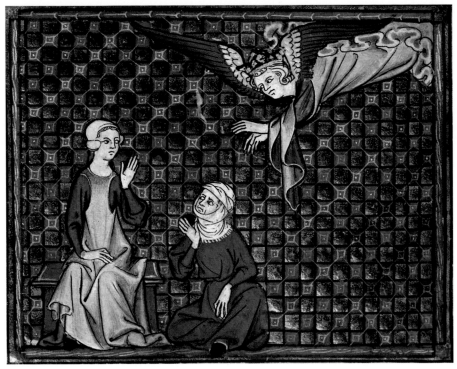

Fig. 8. *Semele, Juno and Jupiter from Ovide Moralisé*, ca. 1313. Rouen Bibliothèque municipale, MS 0.4, fol. 77v.

Fig. 8a. *Semele, Juno and Jupiter*, Rouen Bibliothèque municipale, MS 0.4, fol. 77v.

parallel God's gift of love.[16] The story of Semele (3.865-998) is reframed to tell how her love for Jupiter was a result of her love of drink, a fatal genealogical trait that she passes on to her son. The disguised Juno is painted as a false prophet; in fact, the devil incarnate. Bacchus, on the other hand, is a Christ-like figure, who liberates truth and delivers man from the devil's clutches. A copy from around 1313, now in Rouen, includes the first visual representations of the story since antiquity.[17] On one page the amorous couple is seen seated on a bench demurely holding hands (**Fig. 7**), while on the next Semele is counselled by the deceitful Juno as Jupiter swoops in from above with his thunderbolt in hand (**Fig. 8**). Christine de Pizan's *Epistre Othea a Hector* was written during the first decade of the fifteenth century as a political allegory for members of the royal court of King Charles VI.[18] It follows the model of *Ovide moralisé* in portraying the characters as bearers of either good or bad moral truths. She largely ignores the erotic content of the original stories, focusing instead on the spiritual lessons to be learned; virtues to be encouraged and vices to be avoided.[19] Thus, the tale of Semele (62) is used to warn readers of the inherent danger in revealing secrets. Semele is not only deceived by Juno, but she is deceived by her lover, who in the process of hiding the truth

Fig. 9. *Semele and Juno Disguised as Her Old Nurse* from Christine de Pizan, *Epistre Othéa a Hector*, c. 1315. British Library, London, Harley MS 4431, fol. 123v.

turns her into an adulteress. Semele's sin is the desire to know too much. Christine is thought to have determined the content of the illustrations, which in keeping with the text are austere and unsensual. The story of Semele is illustrated only by a conversation between the heroine and Juno disguised as her old nurse (**Fig. 9**).[20]

During the fourteenth century in Italy there was also a renewed interest in classical mythology as a guide to contemporary life. Dante Christianised the story of Semele in *Paradiso* (21.4-12 and 23.28-33) by creating a parallel between her death in the wake of Jupiter's divine presence and the protagonist's transformative experience of the Incarnate Christ, which makes him strong enough to bear Beatrice's smile. Whereas in Ovid the union between human and divine love failed, in Dante it is given a redemptive nature: death is replaced by eternal life.[21] In *Amorosa visione* (18.1-42) Boccaccio firmly placed the blame for Semele's death on Juno, who had given her false advice. The episode is a small part of the larger triumph of Love, which is described as a fresco depicting fifty-eight famous love affairs. According to Boccaccio the paintings are worthy of contemplation because they illustrate how love fills one with joy, as long as it is not 'satiated by a vile act' (29.55-69).[22] Although the poem was composed in 1342 and widely circulated in manuscript form, it was not published until 1521.[23] In the mid-1350s Boccaccio repeated the story of Semele in *Genealogia deorum gentilium* (2.64 and 5.25). His primary source was the compilations and commentaries by authors such as Fulgentius, who provided rationalized explanations for the classical tales.[24] But unlike the mythographers, who told the stories in compartmentalized segments, Boccaccio ordered the myths into a genealogical table with the explicit intention of revealing hidden truths to a modern generation. Semele's death is explained as a metrological phenomenon in which the fire of Jupiter is mixed with the air of Juno and comes crashing down

Fig. 10. Baldassarre Peruzzi, *Jupiter and Semele*, c. 1508. Stanza dei Fregio, Villa Farnesina, Rome.

to earth as a thunderbolt. By the beginning of the fifteenth century *Genealogia* had become a valuable reference guide to Greek mythology, although the first Italian edition did not appear until 1547.[25] Perhaps the most influential text of the period was Giovanni dei Bonsignori's *Ovidio methamorphoseos vulgare,* which was written between 1375 and 1377.[26] As in *Ovide moralisé* each story was followed by an allegorical explanation. But unlike *Ovide moralisé,* which had been written for the French court, Bonsignori's translation was aimed at a much broader public. The tale of Jupiter and Semele was used as a metaphor for the production of wine. Semele was the grape whose seed was fertilized by Jupiter thus producing wine in the form of Bacchus. But the reader is warned that wine should be tempered by water so that it can do no harm. Bonsignori's explanation clearly inspired writers such as Marsilio

Ficino, who in 1489 in the dedicatory letter to Lorenzo de' Medici at the beginning of *De vita* draws a parallel between Semele and grapes ripening on the vine under the heat of the sun. Despite its popularity, Bonsignori's translation had little to do with the way the classical myths were depicted. It was not until 1497, when the text was published for the first time with fifty-two woodcuts, that its full impact on the visual arts was felt.[27] This surge of interest, however, did not include the story of Jupiter and Semele, since that episode was not chosen for illustration.

One of the earliest Renaissance representations of the Jupiter and Semele story forms part of Baldessarre Peruzzi's frieze which decorates a room on the ground floor of the Villa Farnesina in Rome (**Fig. 10**).[28] Painted shortly after 1508, the frieze depicts the *Labours of Hercules* and a number of other scenes all of which are

Fig. 11. *Jupiter and Semele* and *The Birth of Bacchus* from Francesco Colonna, *Hypnerotomachia Poliphili*, 1499, p. 170.

Fig. 12. *Jupiter and Semele* from Niccolò degli Agostini's *Ovidio metamorphoseos* tradotti, 1522, fol. d ɪɪɪɪ ʀ.

found in the *Fabulae* of Hyginus. Peruzzi, who seems to have been unaware of Bonsignori's Ovidian illustrations, based his scenes on antique sarcophagi. Semele's demise is particularly reminiscent of battle sarcophagi depicting soldiers being clubbed to death. In this case, however, Jupiter Fulminator is seen aggressively attacking his lover with a thunderbolt. Another early Renaissance depiction of the Jupiter and Semele myth appears in the 1499 edition of Francesco Colonna's *Hypnerotomachia Poliphili* (**Fig. 11**).[29] The book recounts a dream in which Poliphilo sees four triumphant chariots celebrating the amorous pursuits of Jupiter. Jupiter's lovers are not named but they are easily identifiable as Europa, Leda, Danaë and Semele, since each chariot is decorated with panels derived from these well-known Ovidian myths. As Edgar Wind pointed out, the elaborate descriptions make it clear that these particular love interests were chosen because they could also be used as personifications of the four elements.[30] The fourth chariot, which is synonymous with fire, had wheels of Arcadian asbestos that once lit resisted extinction. Its

right-hand panel showed 'a venerable pregnant lady to whom almighty Jupiter was appearing in his divine form, as he does only to Juno, with such thunders and lightnings that she caught fire and burned to ashes. A divine child was extracted from the combustion'.[31] On the left of the accompanying woodcut, Jupiter appears in all his combustible glory above the burning bed of his star-crossed lover, while to the right a group of maidens pull a child from the now ash-covered bed. The *Hypnerotomachia* woodcut served as the prototype for the illustration of Jupiter and Semele in Niccolò degli Agostini's 1522 Italian verse translation of Ovid (**Fig. 12**), which added twenty new woodcuts to those published earlier by Bonsignori.[32] In the new Semele woodcut the fatal encounter with Juno is also included behind a door on the left side of the scene. This enlarged scene was repeated on a maiolica plate commissioned in 1535 from the workshop of Guido Durantino in Urbino (**Fig. 13**).[33] The Agostini woodcut may have also inspired a small panel attributed to Jacopo Tintoretto that probably decorated a piece of furniture

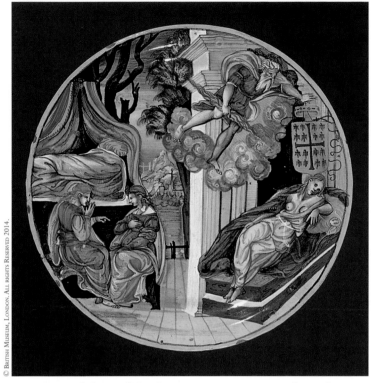

Fig. 13. Workshop of Guido Durantino, *Jupiter and Semele*, 1535. Maiolica plate. British Museum, London, inv. no. 1855, 12-1, 44.

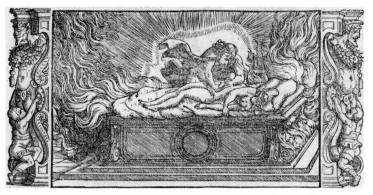

Fig. 15. Giovanni Antonio Rusconi, *Jupiter and Semele* from Lodovico Dolce's *Le trasformationi*, 1553.

(**Fig. 14**).[34] Lodovico Dolce's *Le trasformationi*, which was published in 1553, enjoyed remarkable success in part because of the more elaborate illustrations provided by Giovanni Antonio Rusconi.[35] In Rusconi's *Jupiter and Semele* woodcut a storm of fire envelops both figures (**Fig. 15**). Jupiter is depicted gently pulling the baby from a 'window' in the dead Semele's womb; a remarkable medical procedure that mirrors

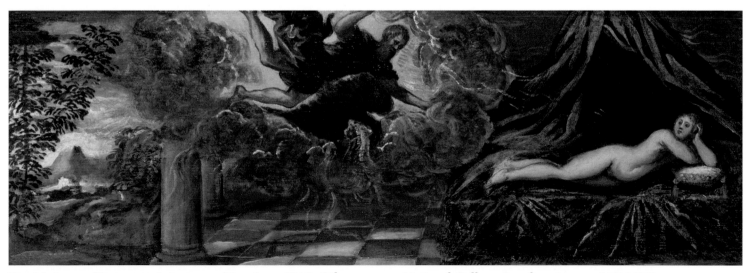

Fig. 14. Jacopo Tintoretto?, *Jupiter and Semele*, c. 1545. Oil on canvas, National Gallery, London, inv. no. NG 1476.

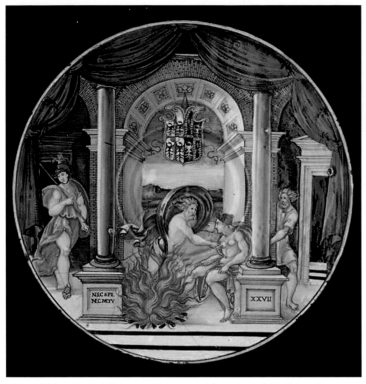

Fig. 16 Nicola da Urbino, *Jupiter and Semele*, 1524. Maiolica plate. National Gallery of Victoria, Melbourne, inv. no. 4710.3.

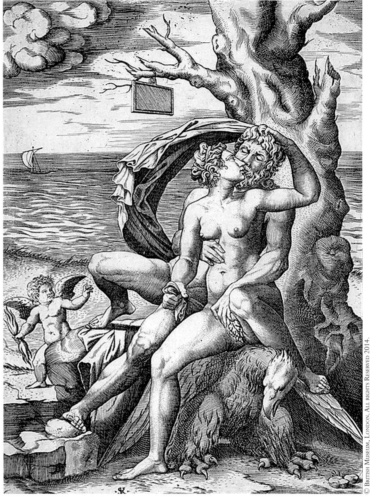

Fig. 17. Attributed to Marco Dente, *Jupiter and Semele*, c. 1520. Engraving. British Museum, London, inv. no. H,7,48.

contemporary descriptions of a Caesarean birth.[36]

While the woodcuts in illustrated editions of Ovid closely followed the text, other artists were more intent on exploiting the inherent sexual nature of the myths. A glimmer of this new trend is already apparent on a maiolica plate commissioned from Nicola da Urbino in 1524 by Eleonora Gonzaga as a gift for her mother Isabella d'Este (**Fig. 16**). The plate is part of an elaborate service, comprising more than twenty pieces most of which depict mythological scenes.[37] Around half of the plates and bowls were based on the Bonsignori woodcuts but since the story of Semele had not been illustrated, Nicola was compelled to invent

his own version of incineratory passion. He depicts Jupiter caressing the breast of an indecorously seated nude Semele, who appears oblivious to the fire burning at her lover's feet. Eleonora had written to her mother saying that she hoped the set might be used at her country estate of Porto, because it was a '*cosa da villa*'.[38] Perhaps she felt that the libidinous myths were more appropriate for a rural retreat, since like the

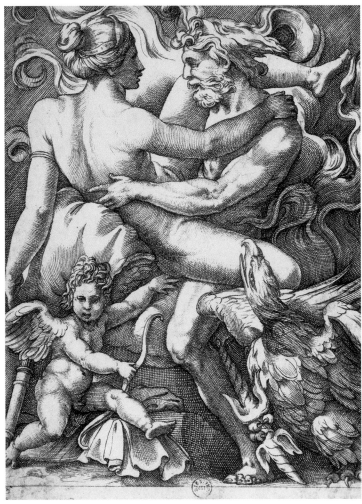

Fig. 18. Gian Giacomo Caraglio, *Jupiter and Semele*, 1527. Engraving. Bibliothèque Nationale, Paris.

Fig. 19. Giulio Romano, *The Birth of Bacchus*, c. 1533. Pen and brown ink and brown wash over black chalk. J. Paul Getty Museum, Los Angeles, inv. no. 95.GA.27.

Belvedere of her Uncle Alfonso country estates were often intended as places of sensual escapism. Pure sensual escapism must also have been behind a number of prints and drawings originating in the 1520s in the workshop of Giulio Romano. In particular, a print attributed to Marco Dente depicts Jupiter kissing Semele while caressing her genitals (**Fig. 17**).[39] Since the narrative content of the print is minimal, it is not

easy to identify Jupiter's love interest. However, the thunderbolt prominently held by the young Cupid implies that this is the story of Semele. The most lascivious of Giulio's scenes were to be found in '*I modi*', a set of sixteen prints engraved by Marcantonio Raimondi in 1524 and almost immediately censored by Pope Clement VII. Although today the prints exist only in a fragmentary state, an idea of their explicit content is reflected in a set of twenty prints known as the *Loves of the Gods* (*Gli amori degli dei*) designed by Perino del Vaga and Rosso Fiorentino and engraved by Gian Giacomo Caraglio in 1527.[40] In contrast to *I modi*, the new series did not depict ordinary couples engaged in acrobatic acts of lovemaking but the gods of Mount Olympus, whose erotic exploits were given a certain degree of decorum by virtue of their mythical status. In *Jupiter and Semele* (**Fig. 18**) the almighty god has laid down his thunderbolt to make passionate love to a mere mortal. Flames swirl around the pair, obfuscating

Giulio Romano also designed a cycle of paintings for the Sala di Giove in the Palazzo Ducale of Mantua, which depict genealogical episodes specifically related to the birth and childhood of the Olympian gods. It has been convincingly suggested that the paintings were commissioned by Federico II Gonzaga to celebrate the birth of his son Francesco III on 10 March 1533.[42] There are several preparatory drawings for Giulio's *Birth of Bacchus,* including one that is squared for transfer (**Fig. 19**).[43] In it Semele is seen screaming in pain as Jupiter, accompanied by a flurry of fire-belching winds, wrenches the baby from her womb. The drawing is arranged horizontally while the painting, which seems to have had considerable workshop intervention, has a vertical orientation (**Fig. 20**).[44] It is unclear why the composition was so radically altered in the final painting. The pose of Semele has been reversed and there are multiple changes to other parts of the composition as well. Perhaps, in keeping with the theme of the room, greater prominence was given to the infant Bacchus who is now held by Semele's sister Ino and attended by the nymphs of Nysa who will later nurture him.

Fig. 20. Giulio Romano and workshop, *The Birth of Bacchus*, c. 1533. Oil on panel, J. Paul Getty Museum, Los Angeles, inv. no. 69.PB.7.

꙳ ꙳ ꙳

DOSSO DOSSI AND THE OVIDIAN TRADITION

to a degree the intricacy of their intercourse. The accompanying poem, which tells how Jupiter has been set afire by the power of Semele's beauty, completely ignores the fatal consequences of their act.[41]

So where does Dosso Dossi's painting fit within this melange of the sixteenth-century representations of Jupiter and Semele? Dosso's version is one of the earliest Renaissance depictions of the myth, yet, as we have

48

Fig. 21. Dosso and Battista Dossi, *The Antechamber of the Magno Palazzo's Chapel*, 1531. Fresco. Castello del Buonconsiglio, Trent.

seen, certainly not the first. It is possible that he had access to the woodcuts in the *Hypnerotomachia* or Agostini's 1522 edition of Ovid, but his composition is so markedly different from either of these sources that it is unlikely he consulted them. We know that Dosso was very familiar with the Gonzaga court in Mantua. He was from Tramuschio di Mirandola, a small town just south of the river Po on the border of the Mantuan territory. His proper name was Giovanni Francesco Luteri, but he was nicknamed 'Dosso' after the family's property in Dosso Scaffa (today San Giovanni del Dosso) near Quistello in the Mantovano.[45] It is not known if he received his artistic training in Mantua or Venice nor if he travelled to Rome for the coronation of Leo X in 1513. In the absence of concrete documentation

speculations about his formative years abound.[46] What is known is that on 11 April 1512 he was paid for a large painting with eleven figures (quadrum unum magnum cum undecim figuris humanis) for the Palazzo San Sebastiano, the favourite residence of Francesco II Gonzaga and his wife Isabella d'Este.[47] By 1513 he was working in Ferrara, but he frequently travelled to Venice to buy pigments and he famously accompanied Titian on a trip to Mantua in 1519 to see the work of Mantegna and Isabella's celebrated *studiolo*.[48] It is likely that he returned to the city on other occasions, but there is nothing in his *Jupiter and Semele* to suggest that he was familiar with Giulio Romano's work or the more salacious prints from his circle that were in circulation by the mid-1520s.

Fig. 22. Antonio Lombardo, *The Forge of Vulcan*, 1508-11. Marble relief. The Hermitage, Saint Petersburg, inv. no. 1771.

In June 1531 Dosso and his brother Battista were called to Trent by the Prince Bishop and Cardinal Bernardo Cles to fresco rooms in the Magno Palazzo, a large addition to the medieval Castello del Buonconsiglio.[49] It seems that speed of execution and minimum expense were the cardinal's primary concerns and by September 1532 both bothers had returned to Ferrara. Cles' suggestions for the subjects of the frescoes were generally vague but more than once he specifically asked for scenes from Ovid 'according to what you think is most appropriate, but we rely on your [the supervisor] and his [the painter] judgement'.[50] Dosso and Battista depicted fifteen Olympian gods in the lunettes of the antechamber leading to the chapel (**Fig. 21**). These half-length figures, which appear to be floating on clouds, are seen

at leisure, as if the clouds had parted to give the viewer an expected glimpse of Mount Olympus. At the centre of one wall Jupiter seems almost at ease as he languidly reaches for his thunderbolt. In 1539, only a few years after the frescoes had been completed, Pietro Andrea Mattioli published a lengthy poem describing the decorations in detail as well as the public response to them.[51] Critics, it seems, questioned the suitability of pagan gods at the entrance to the chapel, suggesting apostles would have been more appropriate. Mattioli countered by saying that in ancient Rome generals had forced conquered kings to walk in front of their triumphal chariots and at Trent the chapel was Christ's triumphal chariot before which marched the false gods of antiquity.[52] In the *stua grande*, a room whose decorations are now lost, the Dosso brothers painted scenes from Ovid's *Metamorphoses*. As Thomas Frangenberg first pointed out, rather than consulting the Latin text they turned to Bonsignori's more accessible 1497 vulgate edition, which gave a brief paraphrase of each tale and provided helpful illustrations for a handful of the stories.[53] Comparing Bonsignori's woodcuts to Mattioli's meticulous description of the frescoes, it becomes clear that only the most familiar narratives illustrated in the 1497 edition were chosen to be reproduced in the room. These were then painted in the exact order in which they appear in the text.[54] There is no indication that the Dosso brothers were interested in the allegorical interpretations that accompanied each tale. It is hardly a coincidence that the story of Semele, which was not illustrated, was not included in the *stua grande* cycle.

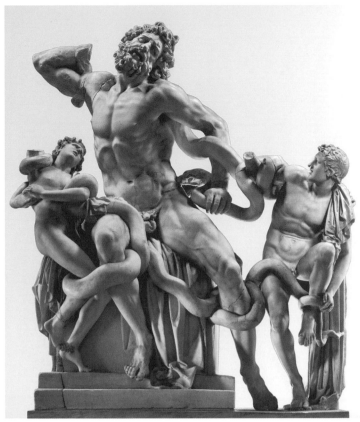

Fig. 23. *Laocoön*, 1st century AD, Marble. Musei Vaticani, Vatican City.

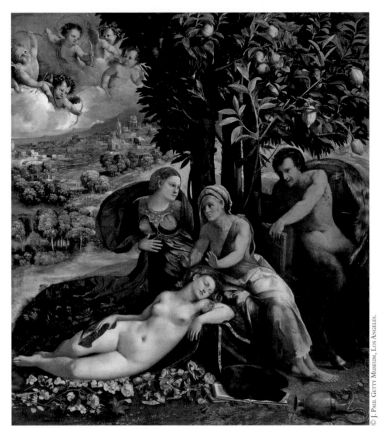

Fig. 24. Dosso Dossi, *Allegory of Pan*, c. 1529-30. Oil on canvas. J. Paul Getty Museum, Los Angles, inv. no. 83.PA.15.

Dosso, of course, may have had access to Bonsignori's Ovid before his trip to Trent, but it would not have provided a visual template for his *Jupiter and Semele*. Without a concrete visual source to draw upon Dosso was free to invent his own narrative. For his provocative depiction of Jupiter's super-heroic anatomy he appears to have turned to Antonio Lombardo's reliefs in the *studio di marmi* in the Castello. The *studio di marmi* was a small room designed to house Alfonso d'Este's extensive collection of antiquities, bronze statuettes, coins, books and glass. Between 1508 and

1511 Antonio decorated it with *all'antica* marble reliefs, one of which depicts *The Forge of Vulcan* (**Fig. 22**).[55] It has been plausibly argued that the seated figure on the left is Jupiter, labouring to bring forth Minerva from the cleft split in his head by Vulcan, whose discarded axe lies at the centre of the relief between his feet.[56] This seated figure of Jupiter is one of the earliest works to reflect the newly excavated Laocoön (**Fig. 23**), which had been unearthed in Rome in 1506.[57] As in the Laocoön, the figure in the relief is about to spring into action from a semi-seated position. As he rises, Jupiter

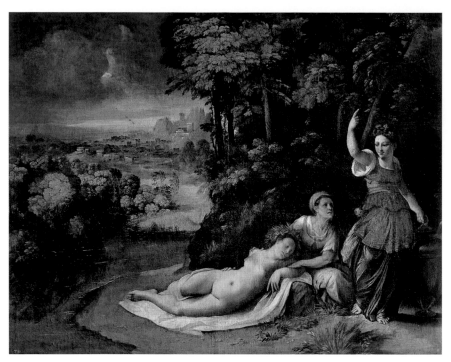

Fig. 25. Dosso Dossi, *Mythological Allegory*, c. 1529-30.
Oil on canvas. Galleria Borghese, inv. no. 304.

presses his weight down with his right hand. Although Dosso reversed the position of Jupiter's legs, he maintained the dynamic energy and accentuated sense of urgency inherent in this pose. Dosso paid careful attention to the musculature of Jupiter's perfectly toned body, but he also introduced a note of decorum by strategically placing a piece of raspberry-red drapery over one of his legs. In Antonio's relief Jupiter's right hand has been damaged so that it is impossible to tell if he once held a thunderbolt. But even without this iconic attribute, it is clear that Dosso found the powerful figure a fitting model for his own Jupiter. Furthermore, both Antonio and Dosso must have been aware that any reference to the recently discovered Laocoön would

flatter Alfonso d'Este, who at the time was considered one of the foremost connoisseurs of classical antiquity.

The setting of Dosso's painting is ambiguous. The thunderous sky suggests that they are out of doors, but the story itself implies that they are in Semele's bedroom and, as we have seen, almost all the Renaissance representations of the myth include a bed. It is likely that they are perched on the edge of her bed—if Semele were standing Jupiter could not tower over her with such terrorizing command and he is clearly pressing his weight down on something—but the voluminous drapery and billowing puffs of smoke completely mask what the couple are seated on. Through the inclusion of just a few key elements, Dosso was able to tell the story of Jupiter and Semele without having to expand the narrative or to fall back on details provided in one specific text. This does not, however, mean that the picture is straightforward. As Mauro Lucco has pointed out, Dosso 'was never an illustrator so much as an improviser, who beginning on the canvas, broadened or collapsed the narrative sequence of the story, selected the facts he wanted, expanded on one event to the detriment of another, embroidered tangential elements and ignored major themes.'[58] Because Dosso constantly revised his compositions as he worked, adding and subtracting key elements and figures, modern scholars have often found it difficult to identify the subject of his paintings. *The Allegory of Pan* (**Fig. 24**) and *The Mythological Allegory* (**Fig. 25**), both of which were painted a few years before his trip to Trent, are cases in point. The sleeping nymphs in the two paintings are remarkably similar, but none of the classical or modern

texts purposed as a unique source accounts for all the details found in either picture. A myriad of suggestions from Ovid's *Metamorphoses* (Vertumnus and Pomana or Pan with either Syrinx or Echo) to Nonnus's *Dionysiaca* (the virgin nymph Nicaea) and Francesco Colonna's *Hypnerotomachia Poliphili* (a priapic garden of sensual delights) have been put forward for *The Allegory of Pan*.[59] Likewise, *The Mythological Allegory* has been variously interpreted as an Ovidian transformation (Syrinx, Diana and Callisto, or perhaps even Semele accompanied by both a false and real nurse awaiting Jupiter), Nonnus's Nicaea or an allegory of Nature, Philosophy and Virtue based on Mario Equicola's *De natura d'amore*.[60] Neither of these paintings, however, relies on one textual source, rather they both allow the viewer to shift through a network of interrelated concepts encompassing ideas from ancient poetry, contemporary literature and the visual arts. This complexity of ideas mingled together in one piece is also found in Dosso's *Jupiter and Semele*. The seemingly unrelated objects at the bottom of the picture are not found in any of the myth's many retellings and must, therefore, be derived from another source.

THE DEADLY SIN OF AVARICE

The toads, moneybag, keys and rocks scattered at the bottom of Dosso's *Jupiter and Semele* (**Fig. 26**) are traditional symbols of avarice or greed. In mediæval moral theology, avarice was the desire to have more

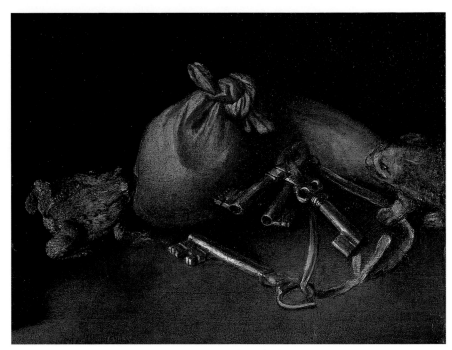

Fig. 26. Dosso Dossi, *Jupiter and Semele*, detail of Fig. 4.

than what was considered absolutely necessary. At its root was the uncontrollable urge to amass material objects and money, but a greedy person also had an insatiable craving to retain what he already possessed. What constituted 'enough' and what was deemed to be in excess was extremely difficult to define.[61] One thing was certain, however, whoever yielded to cupidity would be condemned to a life of unbearable suffering. Although the visual iconography of the virtues and vices was slow to develop, by the twelfth century a clear canon of imagery had evolved in which avaricious men were strangled by their purse strings and weighed down by the burden of their possessions.[62] An early thirteenth-century relief on the façade of Santa Maria Assunta in Fornovo di Taro outside Parma depicts just

Fig. 27. *The Sin of Avarice*, early 13th century. marble. Santa Maria Asunta, Fornovo di Taro.

such a scene (**Fig. 27**).[63] Not only does the avaricious man have three moneybags tied around his neck and a strongbox pushed down on his shoulders, but he has the added torment of his teeth being wrenched from his mouth by a devilish demon. While moneybags and locked chests became common symbols of monetary avarice, the power of possessions and the illusory sense of control they brought could also be portrayed as a kind of sexualized seductiveness or erotic greed.[64] Theologians did not shy from pointing this out. Ambrose of Milan described how Delilah's avarice deceived Samson and Basil the Great compared a rich man's greed to Joseph's attempted seduction by the wife of Potiphar.[65] In the *Inferno* (XIX, 22-24) and again in *Purgatorio* (XIX, 71-75), Dante warned that not only is longing for excess money bad but that any excess in love is dangerous as well.[66]

It was not until the thirteenth century that frogs and toads became specifically identified with avarice, although they had a history of being associated with sinners in general and were a common symbol of lechery.[67] There were biblical plagues of frogs in Exodus, while in the Book of Revelation (XVI, 13-14) three unclean spirits come out of the mouth of the dragon like frogs.[68] In the *Inferno* (II) Dante populates the underworld's marsh with heretical sinners, who like frogs slither about in the swampy waters. Emblematically frogs and toads appear to have been interchangeable, no doubt because the two creatures themselves were not clearly differentiated.[69] Frogs were often described as being very timorous beasts, afraid that the earth they eat would disappear. Around 1230 in *Liber de natura rerum* (IX, 5), Thomas of Cantimpré described toads in precisely the same way, adding that toads were a symbol of avarice and cupidity (*et in hoc avaros et cupidos signat*). Thomas's bestiary was an important source for the *Etymachia*, an anonymous fourteenth-century prose treatise on the seven virtues and vices. Each Christian virtue and deadly sin was personified by a figure riding into battle on a different mount. The beasts were intended to teach moral lessons and, in the written text, a variety of exotic animals was associated with each rider. The illustrations, however, pared the selection down to just one creature that would be familiar to a European audience. In a woodcut entitled *The Devil and the Seven Deadly Sins* Avarice, who holds a moneybag aloft, is depicted riding into battle on the back of the toad (**Fig. 28**). In the *Fior di Virtù*, an anonymous fourteenth-century moralized bestiary, the virtues and vices were each given an animal as an exemplum. After describing misers as those who hoard

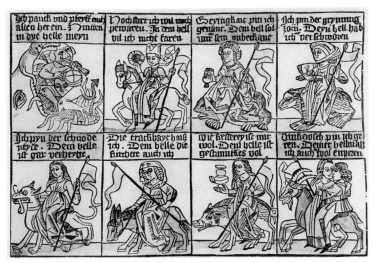

Fig. 28. *The Devil and the Seven Deadly Sins*, c. 1470. Woodcut. Albertina, Vienna, inv. no. 1930/0202.

Fig. 29. *Avarice from Fior di Virtù*, Florence 1491, XVI, Library of Congress, Washington.

what they should spend and spend what they should save, the text compares 'Avarice to a toad that lives exclusively on earth. Out of fear that he might have to go without he never eats as much of it as he needs.'[70] The book proved to be exceedingly popular. There are several illuminated manuscripts in which the animals associated with each virtue and vice are depicted and by the end of the century a variety of printed editions had also appeared.[71] One published in Florence in 1491 depicts the interior of a house where a group of men survey the riches amassed in a strongbox; outside a giant toad surveys his hoard of rocks (**Fig. 29**).[72] The toad was afraid to let go of his precious rocks, even though they were of no use to him. Leonardo da Vinci used the descriptions in the *Fior di Virtù* as the basis for his own bestiary. He compared Avarice to the toad that 'feeds on earth and always remains lean, because it never fills itself—it is so afraid lest it should be without earth'.[73]

Dosso must have been well aware of association between toads and avarice, since one of the woodcuts in Sigismondo Fanti's *Triompho di Fortuna* entitled 'Rota della Avaritia' depicts a greedy woman holding two moneybags above a small toad (**Fig. 30A/B**).[74] Fanti was a Ferrarese humanist and astrologer, who devised a clever game for predicting the future. In 1527 the game was published in Venice as a book dedicated to Pope Clement VII, although it is likely to have been conceived in Ferrara for the amusement of the Este court. It is a game of chance in which, according to the hour of the day or the throw of the dice, a player obtains answers to seventy-two questions about his fate in life. The book contains over three hundred woodcuts, a large number of which include depictions of famous men and women from antiquity to the present. Dosso Dossi is one of a handful of Renaissance painters named in the book and it surely is not a

Fig. 30A. *Rota della Avaritia* from Sigismondo Fanti's *Triompho di Fortuna*, Venice 1527, fol. 27r. The Warburg Institute, London.

Fig. 30B. *Rota della Avaritia* from Sigismondo Fanti's *Triompho di Fortuna*, Venice 1527, fol. 27r (Detail). The Warburg Institute, London.

coincidence that he shares the 'Rota della Fede' with Fanti, the book's author and fellow Ferrarese citizen (**31 and 31A/B**).[75] Attempts have been made to attribute woodcuts in the *Triompho di Fortuna* to Dosso.[76] The complex poses of the historical figures are similar to those found in a number of his paintings,

including the series of *Learned Men of Classical Antiquity* (**Figs. 32** and **33**), and he may have played a role in their design, but in general the woodcuts are too generic to be assigned to a specific hand.[77] The imagery is drawn from a standard repertoire of astrological deities, virtues, vices, animals and the liberal arts, all of which would have been instantly recognizable by games-players. It is an encyclopaedic compendium of human knowledge transformed into a literary pastime.

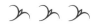

Fig. 31. *Rota della Fede* from Sigismondo Fanti's *Triompho di Forturna*, Venice 1527, fol. 34v. The Warburg Institute, London.

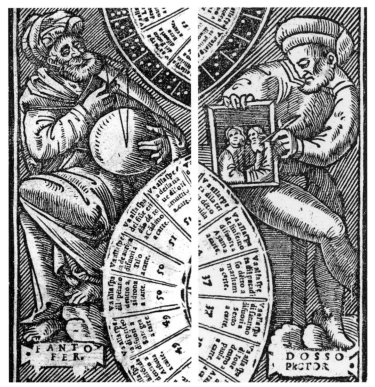

Fig. 31A-B. Details from *Rota della Fede* from Sigismondo Fanti's *Triompho di Forturna*, Venice 1527, fol. 34v. The Warburg Institute, London.

pleasure of Alfonso d'Este's court. Baldassare Castiglione's *Il libro del cortegiano,* which was published in Venice in 1528, opens with an after-dinner game in which the guests are asked to propose another game to be played.[78]

COURTLY GAMES

If Sigismondo Fanti's *Triompho di Fortuna* was a literary pastime conceived as an amusement, then Dosso Dossi's *Jupiter and Semele* might be seen as an equivalent visual entertainment created for the

But leaving this aside, I say that the custom of all the gentlemen of the house was to betake themselves straightway after supper to my lady Duchess; where, among the other pleasant pastimes and music and dancing that continually were practised, sometimes neat questions were proposed, sometimes ingenious

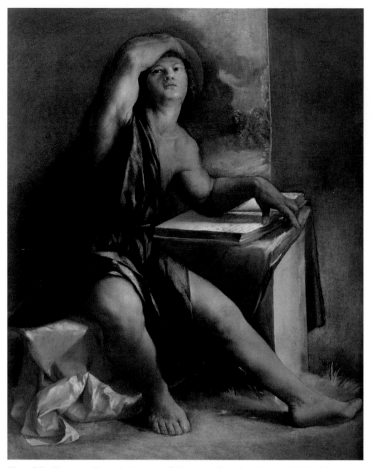

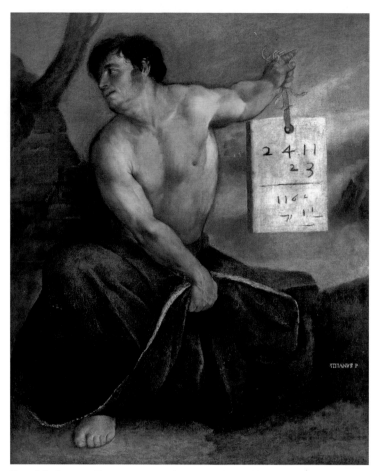

Fig. 32. Dosso Dossi, *Learned Man with a Book*, c. 1520-22. Oil on canvas. Cassa di Risparmio di Ferrara.

Fig. 33. Dosso Dossi, *Learned Man with a Tablet*, c. 1520-22. Oil on canvas. The Chrysler Museum, Norfolk.

games were devised at the choice of one or another, in which under various disguises the company disclosed matters, or biting retorts passed lightly back and forth. Often "devices" (*imprese*), as we now call them, were displayed; in discussing which there was wonderful diversion, the house being (as I have said) full of very noble talents.[79]

The various disguises or veils, as Castiglione describes them, were to be peeled back to reveal what was hidden underneath. The ensuing discussion was meant to provoke endless debate by revealing the possibility of multiple interpretations. There were ancient precedents for such jocular discourse. Marcobius in *Saturnalia* (I.1, 2-3) described how at dinner conversations were meant to take on less serious topics. Love, he advised, should be treated with diversity and charm.[80] In the fifteenth century Leon Battista Alberti wrote a series of witty pieces that were intended to be read over dinner, hence their name *Intercenales*. They

drew moral lessons through the use of humour and visual allegory.[81] As Luisa Ciammitti has pointed out, the idea of narrating a story through objects recalls the widespread taste at Italian courts for figural rebuses, hieroglyphics, riddles and emblems.[82]

By choosing to combine a classical myth with symbols of avarice, Dosso invited his viewers to contemplate the juxtaposition of seemingly incongruous stories and objects. There might be multiple interpretations. At first, it might be understood as a new gloss on erotic greed in which Semele foolishly followed the bad advice of a worldly old nurse and asked for sexual favours beyond her control. The fatal consequence of Semele's insatiable desire to make love to Jupiter in his full glory, just as Juno herself did, is implied by the smoke beginning to consume her body. An astute viewer would have known that toads or frogs were symbols of avarice and that Semele's moral sin had been to demand too much. But a shrewd viewer might have known that frogs were not always considered to be evil. They were also symbols of the Resurrection.[83] In his *Natural History* (VIII, xxxii) Pliny the Elder described at some lengthen the protective power of amulets made from the bones of frogs and toads and the life-saving remedies that could be concocted from their flesh: medicines that restored life. It was believed that frogs were frozen solid in winter and thawed back to life in spring. Jupiter and Semele's son, Bacchus, were also associated with the springtime renewal of life. The latter was called the twice born, because he issued forth from both his mother's womb and his father's thigh. Other myths told of his death and rebirth. In the wake of Juno's rage he was torn to pieces but emerged reborn from the darkness of the underworld every three years. According to legend, after he was killed, his member was carried away in a basket and became the nucleus of fresh life. Yearly Bacchanals were held to mark the rebirth of the 'god who could never have a tomb', a clear allusion to the idea of death and resurrection.[84] Not surprisingly, Christian writers regarded Bacchus as a Christ-like figure, whose three years underground were seen as a parallel to Christ's three days in the tomb.[85] In Dosso's painting the keys might symbolize something more than the locking of a strongbox, they might also be a reminder of Saint Peter unlocking the gates to the kingdom of heaven. One might even go as far as to suggest that the poses of Jupiter and Semele recall pictures of the Annunciation, where Gabriel rushes in with a lily held high above his head and the Virgin clasps her hand to her breast as she recoils in fright. Dosso's simplicity is deceptive. What appears at first glance to be a picture without a narrative framework is, in effect, a complex riddle of elements that relate to one another in a variety of ways and are open to a series of interpretations.

It is tempting to associate Dosso's *Jupiter and Semele* with his *Jupiter Painting Butterflies* (**Fig. 34**), which has recently been acquired by the Wawel Royal Castle-State Art Collections in Krakow.[86] In the Krakow picture a youthful Jupiter is depicted seated at an easel, holding a palette, maulstick and brushes. His legs are crossed in a leisurely fashion and his thunderbolt has been casually discarded beneath the easel. At his side is Mercury, who places his finger to his lips to warn an approaching maiden that Jupiter is not to be disturbed.

Fig. 34. Dosso Dossi, *Jupiter Painting Butterflies*, c. 1524. Oil on canvas. Wawel Royal Castle-State Art Collections, Krakow.

The starting point for the picture was one of the dialogues in Alberti's *Intercenales* in which Virtue has come to complain to Jupiter about being beaten, stripped bare and dragged through the mud by Fortune.[87] Alas, she is left to wait outside Jupiter's palace for more than a month while the gods inside watch cucumbers blossom and ensure that the wings of butterflies are beautifully painted. Mercury is finally dispatched to tell her that Jupiter and the other gods have no wish to quarrel with Fortune and she is sent away in despair. Dosso's picture is not a straightforward retelling of Alberti's dialogue and thus its subject has been called into question. It has been pointed out that the supposed figure of Virtue is neither nude nor even in tattered garments. She has therefore been reclassified as Flora, the goddess of springtime, and the painting

Fig. 35A. *Semele*, detail from *Jupiter and Semele*. The Matthiesen Gallery, London.

Fig. 35B. Antonio di Giovanni Minello, *Grieving Heroine*, 1520s. Marble. Private collection, New York.

reinterpreted as an allegory of the changing seasons.[88] The fading flowers of springtime are replaced by the butterflies of summer taking wing on Jupiter's canvas. Ovid describes in the *Metamorphoses* (I:116-18) how Jupiter shortened the bounds of eternal spring to initiate the four seasons of the year. Without a strong visual tradition to draw on Dosso was able to recast the story of Virtue's defeat into a multi-layered dialogue about Jupiter's dominance over nature. As Giancarlo Fiorenza has pointed out, the viewer is challenged to recognize the poetic distance between Alberti's text

and Dosso's canvas.[89] Just as in *Jupiter and Semele*, the ingenious mingling of antique literary sources and contemporary pictorial devices invite complex readings in which multiple layers of meaning emerge.

Scholars have generally agreed that *Jupiter Painting Butterflies* was painted around 1523-24.[90] The stocky and muscular poses, which are closely related to the figures in Antonio Lombardo's reliefs for the *studio di marmi*, and the reduction of the background to a spatially unrelated landscape are typical of Dosso's work from this period. These are characteristics shared with

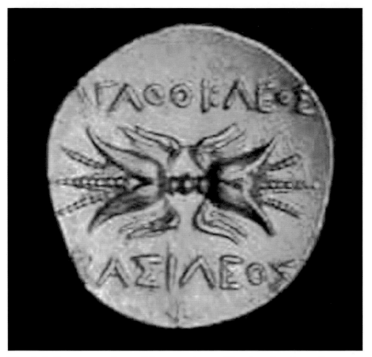

Fig. 36. Reverse of a gold stater issued by Agathocles of Syracuse, 317-289 BC.

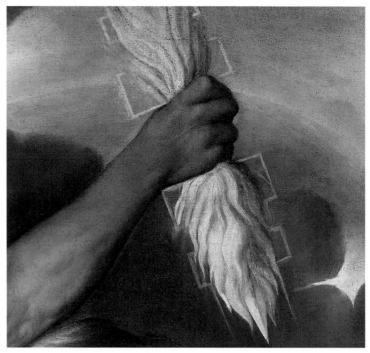

Fig. 37A. Dosso Dossi, *Jupiter and Semele* (detail). The Matthiesen Gallery, London.

Jupiter and Semele, which also must date from this time. In both pictures meticulous attention has been paid to the details. Jupiter's robes are decorated with intricate borders of gold filigree spun on the surface like cotton candy. The wings on Mercury's feet and the blue ribbons in Semele's hair are rendered with remarkable fineness. Flora and Semele's broad, expressive faces with parted lips are typical of Dosso's women, who seem to have been inspired by contemporary *all'antica* female heads such as Antonio di Giovanni Minello's *Grieving Heroine* (**Fig. 35B**).[91] Their hair is partly woven into a braid and tied with interlacing ribbons or flowers, which encircle the head like a crown. The hand clasped to their breasts suggests a moment of

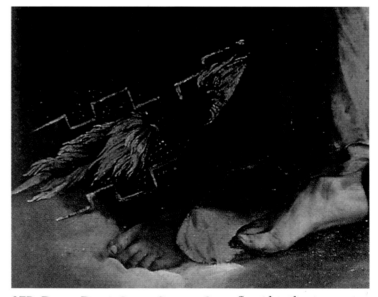

37B. Dosso Dossi, *Jupiter Painting Butterflies* (detail). Wawel Royal Castle, Krakow.

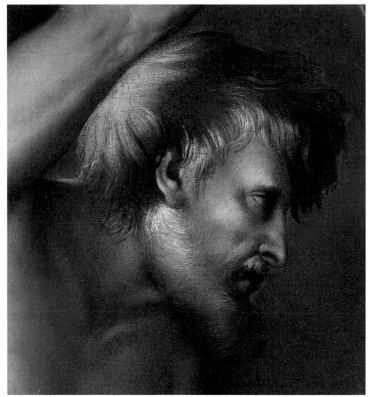

Fig. 38A. Dosso Dossi, *Jupiter Painting Butterflies* (detail).

Fig. 38B. *Jupiter and Semele* (detail). The Matthiesen Gallery, London.

sheer desperation beyond the power of words. Jupiter's thunderbolt of twisted flames and geometric spikes is identical in both pictures and was most likely based on the reverse of antique coins such as those issued by Agathocles of Syracuse (**Figs. 36 and 37A/B.**).[92] The straight-nosed, fully-bearded figures of Jupiter are also uncannily similar, although they seem to represent the almighty god at two separate stages of his life. The youthful dark-haired Jupiter sits at his easel, controlling the seasons through the artistry of paintings, while the more mature grey-bearded Jupiter causes the heavens to unleash their power through the military might of his thunderbolt. One represents Jupiter of the Bright Sky, maker of rainbows and purveyor of hope and light. The other depicts Jupiter of the Dark Sky, controller of the clouds, wind, rain and meteorites (**Figs. 38A/B**).

Could it be that the two pictures were consciously conceived to present the flip sides of Jupiter's personality? They make an odd pair since one is horizontal and the other vertical, but they may have been planned to fit within a specific location that required pictures of the differing sizes and shapes. Dosso's series of *Learned Men of Classical Antiquity* is

composed of canvases in both a horizontal and vertical format as were Giulio Romano's pictures for the Sala di Giove in Mantua. Perhaps, like this latter series, Dosso's paintings formed part of a complete room dedicated to the life of Jupiter. Unfortunately we lack any written record which might confirm this. But we do know that Alfonso d'Este identified himself with Jupiter and it is possible to see both pictures as allegorical representations of the duke. In times of peace the duke turned his attention to the arts. He was, in fact, one of the foremost patrons of his day. In times of war he unleashed the firepower of his formidable arsenal. In one of the Castello's towers he personally oversaw the manufacture of the *granata svampante*, his own Jovian weapon of choice. The paintings also seem calculated to appeal to Alfonso's taste for erotic imagery carefully cloaked in classical learning. At his court the reading and interpretation of ancient texts was strongly influenced by the rising prestige of local vernacular literature and fundamental Christian teachings. In *Jupiter and Semele* Dosso was able to assimilate and transform a classical myth into an original pictorial invention by combining it with well-known Christian ideas about morality. The painting invites viewers to work through a network of related ideas and textual allusions. In this sense it becomes the ideal courtly game in which the fatal attraction of sex and avarice is wittily unmasked as a risky adventure for anyone save perhaps the omnipotent Alfonso.

BEVERLY LOUISE BROWN

1. The statuette is from the sanctuary at Dodona, see V. G. Kallipolitis and Evi Touloupa, *Bronzes of the National Archaeological Museum of Athens*, Athens, n.d., pp. 19-20, no. 13. A similar piece, also from Dodona, is in the Antikensammlung Staatliche Museen, Berlin, inv. no. Misc. 10561, see Adolf Greifenhagen, *Antike Kunstwerke,* Berlin 1966, II, p. 45, nos. 17-18. A typical coin of this type is a silver tetradrachm minted in Zankle-Messana in 461 BC, now in the Royal Library of Belgium, Brussels, see Arthur Bernard Cook, *Zeus: A Study in Ancient Religion,* 3 vols., Cambridge 1914-40, III, pt. 2, p. 1153. For the gradual decline over time of images of Jupiter hurling a thunderbolt, see Cook, II, pt. 1, pp. 723-63.

2. See, for example, Marsilio Ficino, *Commentary on Plato's Symposium on Love,* Jayne Sears, tr., Dallas 1985, 5.13 and Vincenzo Cartari, *Le imagini de i dei de gli antichi,* Ginetta Auzzas, Federica Martignago, Manlio Pastore Stocchi and Paola Rigo, eds., Vicenza 1996, pp. 132-33.

3. Hartmut Biermann, '*orbis - Jupiter optimus maximus - sol invictus*: Ein Beitrag zur Herrscherallegorie des 15. Jahrhunderts', in Victoria V. Flemming and Sebastian Schütze, eds., *Ars naturam adiuvans: Festschrift für Matthias Winner,* Mainz am Rhein 1996, pp. 117-31 and the comments in Vincenzo Farinella, *Dipingere Farfalle: 'Giove, Mercurio e la Virtù' di Dosso Dossi. Un elogio dell' 'otium' e della pittura per Alfonso I d'Este,* Florence 2007, p. 46-48 and Giancarlo Fiorenza, *Dosso Dossi*: *Paintings of Myth, Magic, and the Antique*, University Park 2008, p. 64.

4. Strozzi, *Borsiad,* I. 362-64: Illum etenim nasci volumus, quo numina ritu/nascuntur, nullis vinclis nes legibus ullis/mortalis thalami debentem. Transcribed in Walther Ludwig, *Die Borsias des Tito Strozzi: Ein Lateinisches Epos der Renaissance,* Munich 1977, p. 86. See also, Kristen Lippincott, 'The neo-Latin historical epics of the north Italian courts: an examination of 'courtly culture' in the fifteenth century', *Renaissance Studies,* 3 (1989), pp. 415-28 and Jane Fair Bestor, 'Marriage and Succession in the House of Este: A Literary Perspective', in Dennis Looney and Deanna Shemek, eds., *Phaethon's Children: The Este Court and Its Culture in Early Modern Ferrara,* Tempe 2005, pp. 51-85.

5. Scipio Balbus, *Pulcher Visus Calliopsis Divi Alphonsi Ferrariensium*

Ducis, Bologna s.d. An Italian translation of the poem appears in Gianna Pazzi, *Le 'Delizie Estensi' e l'Artiosto: Fasti e piaceri di Ferrara nella Rinascenza,* Pescara 1933, pp. 45-50. For the description of the golden globes see p. 49: Lo splendito ingress s'innalza sopra ben ordinati gardini i quali sono sostenuti da molti anelli vagamente intrecciati. Il tetto è adorno di dorati globi, risplendenti di tre fiamme, dello splendore delle quali si giova il padre stesso della luce.

6. Fiorenza, *op. cit.* (as in note 3), p. 64 also assumes that the father of light is Jupiter, but Farinella, *op. cit.* (as in note 3), p. 96, n. 80 cautions that the line could also refer to Apollo.

7. Andrea Bayer, 'Dosso's Public: The Este Court at Ferrara', in Andrea Bayer, ed., *Dosso Dossi: Court Painter in Renaissance Ferrara,* exh. cat. Metropolitan Museum of Art, New York 1998, pp. 45-46; Chiara Toschi Cavaliere, 'Della "granata svampante" e di altri fuochi', in *L'aquila bianaca: Studi di storia estense per Luciano Chiappini* [*Atti e Memorie della Deputazione Provinciale di Storia Patria,* 17 (2001)], pp. 375-90; Fiorenza, *op. cit.* (as in note 3), pp. 55-71; Farinella, *op. cit.* (as in note 3), pp. 51-55; Francesco Pertegato and Daniele Alberti, 'Scoperta la "granata svampante" i Alfonso I in una residenza estense finora ignorata, *Kermes,* 89 (2013); and Paola Di Pietro Lombardi, 'Le imprese estensi come ritratto embelmatico del Principe', in *Gli Estensi: La Corte di Ferrara,* Modena 1997, p. 212. Around 1505, Alfonso had the arms and *imprese* of his father, Duke Ercole I, painted over with the *granata svampante* in a Breviary now in the Biblioteca Estense Universitaria, Modena, Lat. 424=Ms. V. G. 11. The device also appears throughout Alfonso's Book of Hours, which must have been completed by 1511 and is now in the Museu Gulbenkian, Lisbon, L.A. 149, see Jonathan J. G. Alexander, 'Matteo da Milano, Illuminator', *Pantheon,* 50 (1992), pp. 32-45 and Hermann Julius Hermann, *La miniature Estense,* Modena 1994, pp 166-83.

8. Paolo Giovio, *Dialogo dell'imprese militari e amorose,* Maria Luisa Doglio, ed., Rome 1978, pp. 88-89.

9. Oil on canvas, 180 x 150.5 cm. The picture first appeared at Sotheby's London, 3 July 2013, lot 30. Dosso worked for the duke throughout the 1520s and 1530s. For a list of payments made to Dosso, see Alessandra Pattanaro, 'Regesto della pittura a Ferrara (1497-1548)' in Alessandro Ballarin,

Dosso Dossi: La pittura a Ferrara negli anni del ducato di Alfonso I, 2 vols., Cittadella 1994-95, I, pp. 111-79. Unfortunately the payments rarely specify the subject matter, although they do occasionally mention that he is working on ceilings, on the decorations of the duke's bedroom or in the chapel of the Belvedere. For example, on 14 May 1524 Dosso was paid for "due quadri", I, p. 145, no. 193; in December 1527 he is paid for 'quarto quadri' for the duke for the Castello, I, p. 149, no. 229; and in October 1536 he received payments for 'depinzere li camini de belvedere', I, p. 162, no. 297. It is impossible to link any of the payments directly with the painting under consideration here.

10. On the history of the early sources, see K. W. Arafat, *Classical Zeus: A Study in Art and Literature,* Oxford 1990, pp. 39-41 and Timothy Gantz, *Early Greek Myth: A Guide to the Literary and Artistic Sources,* Baltimore and London 1993, pp. 472-79.

11. J. D. Beazley, *Attic Red-Figure Vase-Painters,* 3 vols., 2nd ed., Oxford 1963, I, p. 202, no. 87. Cook, *op. cit.* (as in note 1), III, pt. I, pp. 23-29, n. 6, lists a number of other Attic vases with similar scenes. Karl Kilinski III, 'Greek Masculine Prowess in the Manifestations of Zeus', in Frances Van Keuren, ed., *Myth, Sexuality and Power: Images of Jupiter in Western Art,* Louvain-Le-Neuve 1998, pp. 29-43. Arafat, *op. cit.* (as in note 10), pp. 83-84 raises doubts about the traditional identification of the woman on the London amphora as Semele, suggesting that she might be Aigina.

12. The museum, which was known as the Robert H. Lowie Museum of Anthropology at the University of California at Berkeley, has recently changed its name to the Phoebe A. Hearst Museum of Anthropology. See H. R. W. Smith, *Corpus Vasorum Antiquorum: United States of America, University of California, 5,* Cambridge, Mass. 1936, pp. 48-49 and pls. XLVII-XLVIII; Beazley 1963, *op. cit.* (as in note 11), II, pp. 1343 and 1681; and Sophia Kaempe-Dimitriadou, *Die Liebe der Götter in der Attischen Kunst des 5. Jahrhunderts v. Chr.,* Basel 1979, p. 97, no. 263.

13. Fabius Planciades Fulgentius has sometimes been confused with Fulgentius the anti-Arian bishop of Ruspe (468-533). However, the mythographic work was composed between 540-50 only after the bishop's death. *Mitologiae* was first published in Milan in 1498 and two years later in Venice,

see Gregory Hays, 'The Date and Identity of the Mythographer Fulgentius', *The Journal of Medieval Latin*, 13 (2003), pp. 163-252.

14. On the chronology and dating for these texts, which number over a hundred, see Jane Chance, *Medieval Mythography: From Roman North Africa to the School of Chartres, A.D. 433-1177*, Gainesville 1994 and Jane Chance, *Medieval Mythography: From the School of Chartres to the Court at Avignon, 1177-1350*, Gainesville 2000. Not all of the mythographers mention Semele, but many do.

15. Sebastian Brock, *The Syriac Version of the Pseudo-Nonnos Mythological Scholia*, Cambridge 1971, p. 63 and Jennifer Nimmo Smith, *The Christian's Guide to Greek Culture: The Pseudo-nonnus Commentaries on Sermons 4, 51, 39 and 43*, Liverpool 2001.

16. *Ovidius moralizatus* was written by Pierre Bersuire and later translated into French, see Kimberly A. Rivers, *Preaching the Memory of Virtue and Vice: Memory, Images, and Preaching in the Late Middle Ages*, Turnhout 2010, pp. 255-62. On the moral readings see, Marylène Possamaï-Pérez, *Ovide Moralisé: Essai d'interprétation*, Paris 2006; Renate Blumenfeld-Kosinski, *Reading Myth: Classical Mythology and its Interpretations in Medieval French Literature*, Stanford 1997; and Leonard Barkan, *The Gods Made Flesh: Metamorphosis and the Pursuit of Paganism*, New Haven and London 1986.

17. Bibliothèque municipale, Rouen, MS 0.4. The manuscript dates from 1313 and is the source for later images such those in Bibliothèque de l'Arsenal, Paris, MS 5069. See Carla Lord, 'Three Manuscripts of the "Ovide moralisé"', *The Art Bulletin*, 57 (1975), pp. 161-75.

18. The first manuscript was executed by Christine for Duke Louis d'Orléans around 1400 and has only six miniatures (Bibliothèque Nationale, Paris, MS fr. 848). The second copy was completed under her supervision between 1406 and 1408 for Duke Jean de Berry (Bibliothèque Nationale, Paris, MS fr. 606) and the third was compiled by her around the same time for Queen Isabeau de Bavière (British Library, London, Harley MS 4431). These latter two contain 101 miniatures. For Harley MS 4431, see Elisabeth Taburet-Delahaye, ed., *Paris 1400: Les arts sous Charles VI*, exh. cat. Musée du Louvre, Paris 2004, p. 125, no. 55.

19. Sandra L. Hindman, *Christine de Pizan's 'Epistre Othéa': Painting and Politics at the Court of Charles VI*, Toronto 1986; Jane Chance, 'Illuminated Royal Manuscripts of the Early Fifteenth Century and Christine de Pizan's "Remythifcation" of Classical Women in the *Cité des dames'*, in Angus J. Kennedy, ed., *Contexts and Continuities: Proceedings of the IVth International Colloquium on Christine de Pizan (Glasgow 21-27 2000)*, 3 vols., Glasgow 2002, I, pp. 203-41; Marilynn Desmond and Pamela Sheingorn, *Myth, Montage, and Visuality in Late Medieval Manuscript Culture: Christine de Pizan's "Epistre Othea"*, Ann Arbor 2003; and Rosalind Brown-Grant, *Christine de Pizan and the Moral Defense of Women: Reading Beyond Gender*, Cambridge 2003.

20. By the end of the century the illustrations were widely available in printed editions, see Desmond and Sheingorn, *op. cit.* (as in note 19), p. 3.

21. Kevin Brownlee, 'Ovid's Semele and Dante's Metamorphosis: *Paradiso* 21-23', in Rachel Jacoff and Jeffry T. Schnapp, eds., *The Poetry of Allusion: Virgil and Ovid in Dante's 'Commedia'*, Stanford 1991, pp. 224-32; Kevin Brownlee, 'Dante and the Classical Poets', in Rachel Jacoff, ed., *The Cambridge Companion to Dante*, Cambridge 1993, pp. 117-19; H. David Brumble, *Classical Myths and Legends in the Middle Ages and Renaissance: A Dictionary of Allegorical Meanings*, London and Chicago 1998, p. 307; and Giuseppe Ledda, 'Semele e Narciso: Miti ovidiani della visione nella *Commedia* di Dante', in Gian Mario Anselmi and Marta Guerra, eds., *Le Metamorfosi di Ovidio nella letteratura tra Medioevo e Rinascimento*, Bologna 2006, pp. 17-40.

22. Juan Pablo Gil-Osle, 'Chatty Paintings, Twisted Memories and Other Oddities in Boccaccio's *Amorosa Visione'*, *Studi sul Boccaccio*, 38 (2010), pp. 89-103.

23. On the history of the poem and its sources, see Vittore Branca's introduction to Giovanni Boccaccio, *Amorosa Visione*, Robert Hollander, Timothy Hampton, and Margherita Frankel, trs., Hanover and London 1986, pp. IX-XXVIII.

24. Thomas Hyde, 'Boccaccio: The Genealogies of Myth', *Publications of the Modern Language Association of America*, 100 (1985), pp. 737-45 and Tobias Foster Gittes, *Boccaccio's Naked Muse: Eros, Culture, and the Mythopoeic Imagination*, Toronto, Buffalo and London 2008, pp 16-23.

25. The first Latin edition appeared 1472, but the book was already well known by that time and several indices had already been made by the end of the fourteenth century, see the comments in the introduction of Giovanni Boccaccio, *Genealogy of the Pagan Gods*, Jon Solomon, ed. and tr., Cambridge, Mass. and London 2011, I, pp. viii-xiii.

26. On the history and influence of the Italian editions, see Bodo Guthmüller, *Ovidio metamorphoseos vulgare: Forme e funzioni della trasposizione in volgare della poesia classica nel Rinascimento italiano*, Florence 2008 (originally published as *Ovidio metamorphoseos vulgare: Formen und Funktionen der volkssprachlichen Wiedergabe klassischer Dichtung in der italienischen Renaissance*, Boppard am Rhein 1981).

27. Carla Lord, 'A survey of imagery in medieval manuscripts of Ovid's *Metamorphoses* and related commentaries', in James G. Clark, Frank T. Coulson and Kathryn L. McKinley, eds., *Ovid in the Middle Ages,* Cambridge 2011, p. 277-78. Lord makes the point that despite their copious narrative imagery very few fourteenth- or early fifteenth-century Latin editions of the *Metamorphoses* have survived. She speculates, however, that Bonsignori was likely to have had a missing visual model.

28. Francesca Cappelletti, 'L'uso delle *Metamorfosi* di Ovidio nella decorazione ad affresco della prima metà del Cinquecento: Il caso della Farnesina', in Hermann Walter and Hans-Jürgen Horn, eds., *Die Rezeption der 'Metamorphosen' des Ovid in der Neuzeit: Der antike Mythos in Text und Bild*, Berlin 1995, pp. 126-28 and Christoph Luitpold Frommel, ed., *La Villa Farnesina*, 2 vols., Modena 2003, I, pp. 70-79 and 177-75.

29. Francesco Colonna, *Hypnerotomachia Poliphili*, Venice 1499, Marco Ariani and Mino Gabriele, eds., 2 vols., Milan 1998, I, p. 170.

30. Edgar Wind, *Pagan Mysteries in the Renaissance*, London 1958, p. 139, n. 5. It is also likely that Colonna was influenced by the triumphal scenes in Boccaccio's *Amorosa vision,* see Malcolm Bull, *The Mirror of the Gods: Classical Mythology in Renaissance Art*, London 2005, p. 154.

31. Francesco Colonna, *Hypnerotomachia Poliphili*: *The Strife of Love in a Dream*, Joscelyn Godwin, tr., London 1999, p. 170.

32. *Ovidio metamorphoseos tradotti*, Venice 1522, fol. D iiii r. See Guthmüller 2008, *op. cit.* (as in note 26), p. 294. The same illustrations were repeated in the 1533 edition, see Guthmüller 2008, p. 308.

33. The plate, which is signed and dated, was part of a larger service of mythological scenes most likely commissioned as a diplomatic gift for Anne de Montmorency, Grand-Maître, later Constable of France, whose coat of arms appears above Semele's head, see Dora Thornton and Timothy Wilson, *Italian Renaissance Ceramics: A Catalogue of the British Museum Collection,* 2 vols., London 2009, I, pp. 295-99, no. 174.

34. While we might imagine that the young Tintoretto painted furniture panels, there are no documents connecting him with paintings of this type, see the reservations in Nicholas Penny, *National Gallery Catalogues: The Sixteenth Century Italian Paintings. Volume II: Venice 1540-1600,* London 2008, pp. 128-41 and Vincent Delieuvin and Jean Habert, *Titien, Tintoret, Véronèse…Rivalités à Venise,* exh. cat. Musée du Louvre, Paris 2009, pp. 330-32. Robert Echlos and Frederick Ilchman, 'Toward a New Tintoretto Catalogue, with a Check List of Revised Attributions and a New Chronology', in Miguel Faus Falomir, ed., *Actas del congreso internacional Jacopo Tintoretto,* Madrid 2009, no. 58, suggest that it is by an associate or an assistant of the master.

35. Guthmüller 2008, *op. cit.* (as in note 26), pp. 251-62 and Bodo Guthmüller, 'Bild und Text in Lodovico Dolces *Trasformationi*', in Walter and Horn, *op. cit.* (as in note 28), pp. 58-77.

36. See for example Scipione Mercurio, *La commare o riccoglitrice*, Venice 1601, fol. 216 and the comments in Jacqueline Marie Musacchio, *The Art and Ritual of Childbirth in Renaissance Italy*, New Haven and London 1999, p. 117.

37. An inventory of 1624 lists twenty-four pieces of which twenty-two are known. However, the missing two pieces have been tentatively identified by Mariarosa Palvarini Gobio Casali, ' Il Patrimonio Ceramico dei Gonzaga: I servizi nuziali', *Civiltà Mantovana*, 47, no. 134 (2012), pp. 83-98. See also Jörg Rasmussen, *The Robert Lehman Collection, Volume 10: Italian Majolica,* New York 1989, pp. 110-14, nos. 66-67 and 246-51; and Thornton and Wilson 2009, *op. cit.* (as in note 33), I, pp. 230-36, nos. 143-44.

38. The letter is transcribed and translated in Thornton and

Wilson 2009, *op. cit.* (as in note 33), I, pp. 231 and 234, n. 8.

39. The engraving, B 338 (254), is thought to have come from the circle of Marcantonio Raimondi. The print was censored at some point with a leaf being added to cover Semele's genitals, see Konard Oberhuber, ed., *The Illustrated Bartsch, 27, The Works of Marcantonio Raimondi and His School,* 2 vols., New York 1978, II, p. 33; Bette Talvacchia in *Giulio Romano,* exh. cat. Palazzo Te and Palazzo Ducale, Mantua 1989, p. 286; and Bette Talvacchia, *Taking Positions: On the Erotic in Renaissance Culture,* Princeton 1999, pp. 130-32.

40. Talvacchia, *Taking Positions, op. cit.* (as in note 39), Chapter 7, pp. 125-60; Madeline Cirillo Archer, *The Illustrated Bartsch, 28 Commentary, Italian Masters of the Sixteenth Century,* New York 1995, pp. 97-99; James Grantham Turner, 'Caraglio's *Loves of the Gods*', *Print Quarterly,* 24 (2007), pp. 359-80; and Linda Wolk-Simon in Andre Bayer, ed., *Art and Love in Renaissance Italy,* exh. cat. Metropolitan Museum of Art, New York 2008, pp. 205-8.

41. The print is labeled 'Jupiter on Fire': *Giove in Fiamma / Io, che col folgor spaventar mi vanto / La terra, el cielo, et ogni grande altezza / vinto mi trovo da chi in doglia, en pianto / I suoi seguaci lungamente avezza, / E'l tuo bel viso, donna, in me puo tanto / chio corro in fiama, et ho di ciovaghezza / Hor che farete miseri mortali / S'io preso cedo agli amorosi strali.* On the print in particular, see Stefania Massari and Simonetta Prosperi Valenti Rodinò, *Tra mito e allegoria: Immagini a stampa nel '500 e '600,* Rome 1989, p. 152, no. 59; and Archer, *op. cit.* (as in note 40), pp. 207-8.

42. The series of paintings were sold in 1627 and many of them entered the collection of Charles I in England, see Alessandro Luzio, *La galleria dei Gonzaga venduta all'Inghilterra nel 1627-28,* Milan 1913, p. 130, no. 602. For a listing of all twelve pictures, see John Shearman, *The Early Italian Pictures in the Collection of Her Majesty the Queen,* Cambridge 1983, pp. 129-30. For the particular history of the Semele picture, see Jeremy Wood, 'Nicholas Lanier (1588-1666) and the origins of drawings collecting in Stuart England', in Christopher Baker, Caroline Elam and Genevieve Warwick, eds., *Collecting Prints and Drawings in Europe, c. 1500-1750,* Aldershot 2003, p. 104, n. 102.

43. For the Getty drawing, see Nicholas Turner, *European*

Drawings. 4: Catalogue of the Collections, Los Angeles 2001, pp. 55-57. Other drawings are in the Cabinet des Dessins, Musée du Louvre, Paris, inv. nos. 3483 and 3644, which is a copy of the Getty drawing.

44. Bette Talvacchia, 'Narration Through Gesture in Giulio Romano's "Sala di Troia"', *Renaissance and Reformation,* 10 (1986), pp. 59-60 and Carl Grimm, 'Art History, Connoisseurship, and Scientific Analysis in the Restoration of Giulio Romano's *Birth of Bacchus*', *The J. Paul Getty Journal,* 22 (1994), pp. 31-41. It has been suggested that Rinaldo Mantovano, may have carried out parts of the composition, see *Giulio Romano, op. cit.* (as in note 39), pp. 440-41.

45. The date of his birth is not known, but he is thought to have been born around 1486. For the documents on the family see, Adriano Francheschini, 'Dosso Dossi, Benvenuto da Garofalo e il politico Costabili di Ferrara', *Paragone,* nos. 543-45 (1995), pp. 110-15 [reprinted and expanded in 'Dosso Dossi, Benvenuto da Garofalo, and the Costabili Polyptych in Ferrara', in Luisa Ciammitti, Steven F. Ostrow and Salvatore Settis, eds., *Dosso's Fate: Painting and Court Culture in Italy,* Los Angeles 1998, pp. 143-51] and Carlo Giovannini, 'Nuovi documenti sul Dosso', *Prospettiva,* 68 (October 1992), pp. 57-60.

46. Giorgio Vasari, *Le vite de' più eccellenti pittori, scultori e architettori nelle redazioni del 1550 e 1568,* 6 vols., Rosanna Bettarini and Paola Barocchi, eds., Florence 1966-1997, III, p. 417, said he was a pupil of Lorenzo Costa, who was the primary artist at the court of Francesco Gonzaga in Mantua. Fiorenza, *op. cit.* (as in note 3) p. 13, accepts Vasari's statement. However, Peter Humfrey and Mauro Lucco, 'Dosso Dossi in 1513: A reassessment of the artist's early works and influences', *Apollo,* 147 (1998), pp. 22-30, argue for his artistic training in Venice and suggest that he probably visited Rome early in his career.

47. Carlo d'Arco, *Delle arti e degli artefici di Mantova: Notizie raccolte ed illustrate con disegni e con documenti,* 2 vols., Mantua 1875, II, p. 79. See also Clifford M. Brown and Anna Maria Lorenzoni, 'The Palazzo di San Sebastiano (1506-1512) and the Art Patronage of Francesco II Gonzaga, Fourth Marquis of Mantua', *Gazette des beaux-arts,* 129 (April 1997), pp. 151-58. On the improbability of this being *The Baccanale*

(Museo nazionale di Castel Sant'Angelo, Rome), see Humfrey and Lucco, *op. cit.* (as in note 46), pp. 22-23 and Mauro Lucco in Bayer, *op. cit.* (as in note 7), pp. 164-67, no. 55. On the other hand, Ballarin, *op. cit.* (an in note 9), I, pp. 295-96, no. 100, still accepts the identification with some reservations.

48. Franceschini, *op. cit.* (as in note 45) and Luzio, *op. cit.* (as in note 42), p. 218.

49. On the palace see Thomas Frangenberg, 'Decorum in the *Magno Palazzo* in Trent', *Renaissance Studies,* 7 (1993), pp. 352-78 and Stefano Tumidei, 'Dosso (e Battista) al Buonconsiglio', in Enrico Castelnuovo, ed. *Il Castello del Buonconsiglio,* 2 vols., Trent 1996, II, pp. 131-57.

50. Letter dated between 6-12 February 1532: '...qualche fabula de Ovidio over de altra, secondo che vi paresse esser più al proposito; tamen sì remettemo al iuditio Vostro et suo.' See Fragenberg, *op. cit.* (as in note 49), p. 359.

51. Pietro Andrea Mattioli, *Il Magno Palazzo del Cardinale di Trento,* Venice 1539, reprinted in Michelangelo Lupo, 'Il Magno Palazzo annotato', in Castelnuovo, *op. cit.* (as in note 49), I, pp. 67-231.

52. *Ibid,* p. 116.

53. Thomas Frangenberg, 'A Lost Decoration by the Dosso Brothers in Trent', *Zeitschrift für Kusntgeschichte,* 56 (1993), pp. 18-37. See also the reconstruction of the room in Lupo, *op. cit.* (as in note 51), pp. 170-86.

54. Frangenberg, *op. cit.* (as in note 53), p. 28, speculates that Dosso used an edition of the Bonsignori text dating from 1517, 1519 or 1523.

55. For a reconstruction of the room and the inventory of objects see, Charles Hope, 'Il Camerino di Marmo: ipotesi per una ricostruzione', in Charles Hope, ed., *Il regno e l'arte: I Camerini di Alfonso I d'Este, terzo duca di Ferrara,* Florence 2012, pp. 179-201 and Andrea Marchesi, '"Robe che si trovano nello studio overo camerino di marmo, et nel adorato di Sua Excellentia": presenze e assenze di oggetti d'arte nell'inventario Antonelli del 1559', in *ibid.,* pp. 203-34.

56. The story is told by Hesiod, Pindar, Apollodorous and Pausanias. A convincing case of the latter as Antonio's primary source has been made by Wendy Stedman Sheard, 'Antonio Lombardo's Reliefs for Alfonso d'Este's *Studio di Marmi*: Their Significance and Impact on Titian', in Joseph Manca, ed., *Titian 500 (Studies in the History of Art* 45), Washington 1993, pp. 315-57. It has also less convincingly been suggested the scene depicts Vulcan being told of Venus and Mars's adultery. In which case, Jupiter is identified as the figure standing in the center behind the forge. For a complete discussion of the various interpretations, see Alessandra Sarchi, 'Lo "studio de prede vive"', in Hope, *op. cit.* (as in note 55), pp. 77-118.

57. On the history of the excavation and the early prints, drawings and three-dimensional copies after the Laocoön, see Francesco Buranelli, Paolo Liverani and Arnold Nesselrath, eds., *Laocoonte alle origini dei Musei Vaticani,* exh. cat. Musei Vaticani, Vatican City 2006 and the illustrations in Alessandro Ballarin, ed., *Il Camerino delle pitture di Alfonso I,* 6 vols., Padua 2002-7, V, figs. 21-27. Neither Antonio nor Dosso would have had to travel to Rome to become familiar with the celebrated statue.

58. Mauro Lucco, 'Fantasy, Wit, Delight: The Art of Dosso Dossi', in Bayer, *op. cit.* (as in note 7), p. 20.

59. For a summary of the various suggestions, see Ciammitti, 'Dosso as a Storyteller: Reflections on His Mythological Paintings', in Ciammitti, Ostrow and Settis, *op. cit.* (as in note 45), pp. 83-111; Peter Humfrey in Bayer, *op. cit.* (as in note 7), pp. 203-9, no. 38; and Fiorenza, *op. cit.* (as in note 3), pp. 79-100.

60. For a summary of the various suggestions, see Mauro Lucco in Bayer, *op. cit.* (as in note 7), pp. 209-12, no. 39 and Fiorenza, *op. cit.* (as in note 3), pp. 96-100. See also, Carlo Del Bravo, ' L'Equicola e il Dosso', *artibus et historiae,* 30 (1994), pp. 71-82 and Ross Stuart Kilpatrick, 'Death by Fire: Ovidian and Other Inventions in Two Mythological Paintings of Dosso Dossi (1486-1534)', *Memoirs of the American Academy in Rome,* 49 (2004), pp. 127-51. This latter article, in which the dates of Dosso's birth seem to have been confused with Alfonso d'Este's, is completely unconvincing in its attempt to link the picture with the myth of Semele.

61. Richard Newhauser, *The Early History of Greed: The Sin of Avarice in Early Medieval Thought and Literature,* Cambridge 2000, p. 125.

62. Adolf Katzenellenbogen, *Allegories of the Virtues and Vices in Mediaeval Art*, London 1939, p. 58 and Lester K. Little, 'Pride Goes before Avarice: Social Change and the Vices in Latin Christendom', *The American Historical Review*, 76 (1971), pp. 25-27.

63. Marco Pellegri, *Santa Maria di Fornovo: Chiesa romanica*. Parma 1970.

64. Richard Newhauser, '*Avaritia* and *Paupertas*: On the Place of the Early Franciscans in the History of Avarice,' in Richard Newhauser, ed., *In the Garden of Evil: The Vices and Culture in the Middle Ages*, Toronto 2005, p. 337.

65. For a list of the imagery surrounding avarice in the literature of late Antiquity and the early Middle Ages, see Newhauser, *op. cit.* (as in note 61), pp. 132-41.

66. Carla Casagrande and Silvana Vecchio, *I sette vizi capitali: Storia dei peccati nel Medioevo*, Turin 2000, pp. 100-3.

67. Christopher Gerhardt, ‚Kröte und Igel in schwankhafter Literatur', *Medizinhistorischs Journal*, 16 (1981), pp. 340-57.

68. Simona Cohen, *Animals as Disguised Symbols in Renaissance Art*, Leiden 2008, pp. 77-78.

69. Nigel Harris, *The Latin and German 'Etymachia': Textual History, Edition, Commentary*, Tübingen 1994, p. 318. In Latin frogs are *rana* and toads *bufo, borax* or *rubeta*. The argument of Louis Charbonneau-Lassay, *Le Bestiaire du Christ: La mystérieuse emblématique de Jésus-Christ*, Milan 1940, pp. 819-31, that frogs were seen as marginally better than toads is not borne out by the literary evidence.

70. Nicholas Fersin, *The Florentine Fior di Virtu of 1491*, Philadelphia 1953, p. 43.

71. For the manuscripts, see Otto Lehmann-Brockhaus, ‚Tierdarstellungen der Fiori di Virtù', *Mitteilungen des Kunsthistorischen Institutes in Florenz*, 7, nos. 1-2 (1940-1941), pp. 1-32. He reproduces the illustration of Avarice from the Biblioteca Riccardiana, Florence, MS. 1711. fol. 25r and lists other manuscripts with similar images, see pp. 11-12, n. 49. See also Charlotte Schoell-Glass, 'Verwandlungen der *Metamorphosen*: Christliche Bildformen in Ovid-illustrationen dei Christine de Pizan', in Walter and Horn, *op. cit.* (as in note 28), pp. 40-41. See the list of printed editions in Lehmann-Brockhaus, pp. 28-30; Victor Masséna, Prince d'Essling, *Le livres à figures venitiens de la fin du XVᵉ siècle*

et du commencement du XVIᵉ, 7 vols., Florence 1907-14, I, pt. 2, pp. 348-57; and Fersin, *op. cit.* (as in note 70), pp. xxiv-xxix.

72. Bernard Berenson, 'Alunno di Domenico', *The Burlington Magazine,* 1 (1903), pp. 6-13, assigned the woodcuts to a follower of Domenico Ghirlandaio. See the comments of Lessing J. Rosenwald in Fersin, *op. cit.* (as in note 70), pp. xv-xviii.

73. Codex H, Institut de France, Paris: Il rospo si pascie di terra e senpre sta macro, perchè nõ si satia; tant' è il timore che esssa terra nõ li manchi, see Jean Paul Richter, *The Literary Works of Leonardo da Vinci Compiled and Edited from the Original Manuscripts,* 2 vols., London 1970, II, p. 262.

74. On the book and its history, see Lynn Thorndike, *A History of Magic and Experimental Science*, 8 vols., 1923-58, VI, pp. 469-71; Albano Biodni, 'Sigismondo Fanti e i libri de la sorte', in Sigismondo Fanti, *Triompho di Fortuna*, Modena 1983, pp. 5-20; Lina Bolzoni, *La stanza della memoria: Modelli letterari e iconografici nell'età della stampa*, Turin 1995, pp. 112-17; Geraldine A. Johnson, 'Michelangelo, Fortunetelling and the Formation of Artistic Canons in Fanti's *Triompho di Fortuna*', in Lars R. Jones and Louisa C. Matthew, eds., *Coming About…A Festschrift for John Shearman*, Cambridge, Mass. 2001, pp. 199-205; Patricia Fortini Brown, *Private Lives in Renaissance Venice: Art, Architecture, and the Family*, New Haven and London 2004, pp. 136-40; and Manuela Rossi, ed., *Dea Fortuna: Iconografia di un mito*, exh. cat. Palazzo dei Pio, Carpi 2010, p. 73, no. 35.

75. The other contemporary painters are Mantegna, Perugino, Francesco Francia, Bocaccio Boccino, Sodoma, Peruzzi, Raphael and Giulio Romano. Michelangelo is included as a sculptor and Fanti portrays himself for a second time on the last page of the spheres (fol. 54v) perhaps as a closing signature.

76. Detlev von Hadeln, 'A Ferrarese Drawing for a Venetian Woodcut', *Burlington Magazine,* 48 (1926), p. 301, first suggested that a drawing for the frontispiece in Christ Church Picture Gallery, Oxford (inv. no. 0137) was by Dosso. This drawing is now attributed to Peruzzi, see Christoph Luitpold Frommel, *Baldassare Peruzzi als Maler und Zeichner*, Vienna 1967-68, pp. 137-8, no. 100 and James

Byam Shaw, *Drawings by Old Masters at Christ Church, Oxford*, 2 vols, Oxford 1976, I, p. 117, no.358. Later it was suggested that other pages in the book were by Dosso, see Hans Tietze and Erica Tietze-Conrat, 'Contributi critici allo studio organico dei disegni veneziani del "500"', *Critica d'arte,* 2 (1937), pp. 86-88; Amalia Mezzetti, *Il Dosso e Battista Ferraresi*, Milan 1965, pp. 28 and 54, n. 86; and Felton Gibbons, *Dosso and Battista Dossi: Court Painters at Ferrara*, Princeton 1968, p. 268, no. 197.

77. For the series of *Learned Men of Classical Antiquity,* see Peter Humfrey in Bayer, *op. cit.* (as in note 7), pp. 138-44, no. 22. *The Learned Man with a Book* was previously in the Nicolson Collection in the 1920s, sold Christies 12 May 1935 and with the Matthiesen Gallery 1984; sold to the Barbara Piasecka Johnson Collection from whence once again reacquired by the Matthiesen Gallery.

78. Thomas M. Greene, '*Il Cortegiano* and the Choice of a Game', in Robert W. Hanning and David Rosand, eds., *Castiglione: The Ideal and the Real in Renaissance Culture*, New Haven and London 198, pp. 1-15.

79. Baldassare Castiglione, *La seconda redazione del 'Cortegiano' di Baldassare Castiglione*, Ghino Chinassi, ed., Florence 1968, I.v, pp. 9-10: 'Ma lasciando questo, dico che consuetudine de tutti li gentiluomini della casa era redursi subito doppo cena alla signora Duchessa, dove tra l'altre piacevol feste e musiche e danze che continuamente si usavano, talor si proponevano belle questioni, talor si faceano alcuni giuochi ingegnosi ad arbitrio or d'uno or d'un altro, ne li quali sotto varii velami, alcuna volta scoprivano i circumstanti allegoricamente i pensieri suoi a chi più loro piacea, qualche volta ne nasceano belle disputazioni di diverse materie, o vero si mordea con pronti detti, spesso si faceano imprese (come oggidi chiamiamo): dove de tali raggionamenti maraviglioso piacere si pigliava, per essere, come ho detto piena la casa di nobilissimi ingegni.' For the English, see *The Book of the Courtier by Count Baldasar Castiglione (1528),* Leonard Eckstein Opdycke, trs., New York 1901, I.v, p. 12.

80. This mealtime story-telling tradition continued throughout the medieval period, see C. Jean Campbell, *The Game of Courting and the Art of Commune of San Gimignano, 1290-1320*, Princeton 1997, p. 194.

81. Leon Battista Alberti, *Intercenales*, Franco Bacchelli and Luca D'Ascia, eds., Bologna 2003 and Leon Battista Alberti, *Dinner Pieces*, David Marsh, trs., Binghamton 1987. See also the comments in Fiorenza, *op. cit.* (as in note 3), pp. 142-43, who relates Alberti's amusing tales to the Dosso's decoration in the dining room of the Magno Palazzo in Trent.

82. Ciammitti, *op. cit.* (as in note 59), p. 94.

83. Cohen, *op. cit.* (as in note 68), pp. 77-78.

84. Clement of Alexandria, quoted in Cook, *op. cit.* (as in note 1), I, pt. 1, p. 107.

85. Brumble, *op. cit.* (as in note 21), pp. 48-49.

86. For many years the picture was in the Kunsthistoriches Museum in Vienna. On its early history and a summarization of the various iconographic interpretations, see Peter Humfrey in Bayer, *op. cit.* (as in note 7), pp. 170-74, no. 27. It has recently been the subject of books by Vincenzo Farinella and Giancarlo Fiorenza, see above note 3.

87. Alberti 1987, *op. cit.* (as in note 81), pp. 21-22.

88. This is the latest reading of the picture by Fiorenza, *op. cit.* (as in note 3), pp. 27-48. Gottfried Biedermann, 'Herkules und die Pygmäen: Zum Oeuvre der beiden Dossi', in *Festschrift Richard Milesi: Beiträge aus den Geistewissenschaften*, Klagenfurt 1982, pp. 125-37, had previously suggested that the figure on the right was Flora.

89. Fiorenza, *op. cit.* (as in note 3), p. 48.

90. Gibbons, *op. cit.* (as in note 76), pp. 212-14, no. 78, instead dates it 1529.

91. These types of busts were introduced in the 1490s by Tullio Lombardo, see Alison Luchs, *Tullio Lombardo and Venetian High Renaissance Sculpture,* exh. cat. National Gallery of Art, Washington 2009, pp. 82-83, no. 5 and a comparable bust by Simone Bianco in the Museen zu Berlin, Skulpturensammlung and Museum für Byzantinsche Kunst, pp. 78-79, no. 4.

92. For a variety and evolution of images of Jupiter's thunderbolt, see Cook, *op. cit.* (as in note 1), II, pt. 1, pp. 723-63.

APPENDIX I

AN EARLY BAROQUE LEAF FRAME FOR DOSSO DOSSI'S *JUPITER AND SEMELE*.

An early transitional seventeenth century Baroque bolection frame, with a centred spiral ribbon at the back edge, an ogee frieze decorated with cross-cut acanthus leaves alternating with ribbon loops on a textured ground, and a centred, bound garland of imbricated bay leaves-&-berries at the sight edge. Of exceptionally fine workmanship, with the original matt and burnished water-gilding, this style derives from the crossover of influences between Bolognese and Neapolitan patterns, and perhaps also those of the Spanish empire which ruled the Kingdom of Naples from the early sixteenth century. It is a refinement of the Bolognese leaf frame, with a late Mannerist twist in the tongued loops of ribbon between the leaves. The shallow rebate, hollow backing and thin wall construction are indicative of Spanish craftsmanship.

APPENDIX II

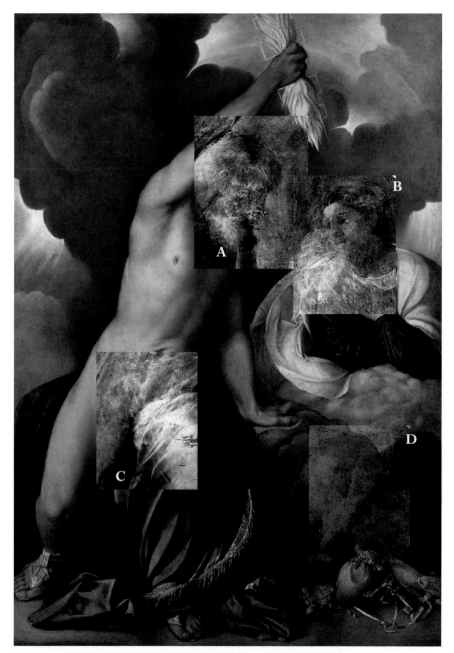

Superimposition of four X-Radiation plates over the image
of *Jupiter and Semele*, The Matthiesen Gallery, London.

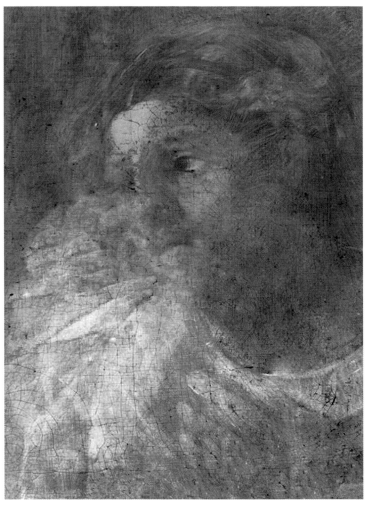

Plate A.
Detail of the Head of Jupiter. This shows a repositioning of the right eye. Dosso has not repainted the whole figure as in the Getty or Borghese allegories merely carrying out an adjustment.

Plate B.
The detail of the head of Semele shows that the collar was originally conceived as white lace and that there were significant extensions to the drapery to the left of the head.

Plate C.
Drapery to the left of Jupiter's knee.

Plate D.
Detail of Semele. An arm is shown extended downwards towards the moneybags. This may be surviving underpainting from an earlier abandoned composition or a painted out figure such as Semele's nurse. Dosso often changed or reused canvases.

EXHIBITION CATALOGUES

THE MATTHIESEN GALLERY, LONDON 1978

Those marked ¶ Matthiesen Gallery in association with Stair Sainty Matthiesen
Those marked ‡ edited and published with Stair Sainty Matthiesen

1979 *British Printmakers 1812–1840*.
 52 pages with 431 items, many illustrated (edited by James Ingram – out of print).

1980 *Symbolist and Art Nouveau Prints – Autumn Catalogue*.
 80 pages fully illustrated (edited by James Ingram – out of print).

1981 *Important Italian Baroque Paintings, 1600–1700*.
 An exhibition in aid of *The Frescoes by Guarino at Solofra* damaged by earthquake.
 Foreword by Alvar González-Palacios.
 100 pages, 22 colour plates, 34 black and white illustrations. £20 or $30 inc.
 p. & p. (scarce).

1981 *Fine Prints and Drawings: England, America and Europe*.
 60 pages with 173 items, many illustrated (edited by James Ingram – out of print).

1983 *Early Italian Paintings and Works of Art, 1300–1480*.
 An exhibition in aid of The Friends of the *Fitzwilliam Museum*.
 Introductory essay by Dr Dillian Gordon on 'Painting Techniques in Italy, 1270–1450'.
 127 pages, 22 colour plates, 34 black and white illustrations.
 £12 or $18 inc. p. & p.

1984 *From Borso to Cesare d'Este, 1450–1628: The School of Ferrara*.
 An exhibition in aid of *The Courtauld Institute Trust Appeal Fund*.
 Ten introductory essays on Ferrara and aspects of Ferrarese art by Cecil Gould,
 Lanfranco Caretti, Claudio Gallico, Vincenzo Fontana, Thomas Tuohy,
 Emmanuele Mattaliano, Giorgio Bassani, Giuliano Briganti, Alastair Smith,
 with charts and Concordat of Ferrarese paintings in British public collections.
 200 pages, 50 colour plates, 84 black and white illustrations. £15 or $23 inc. p. & p.

¶ 1984 *The Macchiaioli*.
 122 pages, fully illustrated (out of print).

¶ 1984 *Three Friends of the Impressionists: Boldini, De Nittis, Zandomeneghi*.
53 pages, fully illustrated (out of print).

1985 *Around 1610: The Onset of the Baroque*.
An exhibition on behalf of Famine Relief in Ethiopia by *The Relief Society of Tigray*.
Introduction by Sir Ellis Waterhouse.
120 pages, 33 colour plates, 22 black and white illustrations (scarce). £12 or $18 inc. p. & p.

‡ 1985 *The First Painters of the King: French Royal Taste from Louis XIV to the Revolution*.
Catalogue by Colin Bailey, including three comprehensive essays by Philip Conisbee,
Jean-Luc Bordeaux and Thomas Gaehtgens. Introduction by Guy Stair Sainty.
Inventory of paintings by the 'First Painters in Public Collections in the USA'.
144 pages, 21 colour plates, 243 black and white illustrations (out of print).

1986 *Baroque III: 1620–1700*.
An exhibition in memory of Sir Ellis Waterhouse and on behalf of *The National
Art Collections Fund*.
Introduction by Sir Peter Wakefield. Essays by Francis Haskell, Cecil Gould,
Francis Russell, Charles McCorquodale and Craig Felton.
152 pages, 15 colour plates, 30 black and white illustrations. £15 or $23 inc. p. & p.

‡ 1986 *An Aspect of Collecting Taste*.
Introduction by Guy Stair Sainty.
68 pages, 24 colour plates, 7 black and white illustrations (out of print).

1987 *Paintings from Emilia, 1500–1700*.
An exhibition held in New York at the Newhouse Galleries Inc.
Foreword by Professor Sydney J. Freedberg. Introduction by Emmanuele Mattaliano.
150 pages, 33 colour plates, 63 black and white illustrations.
£15 or $23 inc. p. & p.

1987 *The Settecento: Italian Rococo and Early Neoclassical Paintings, 1700–1800*.
An exhibition held on behalf of *Aids Crisis Trust (UK)* and *The American Foundation
for Aids Research (USA)*.
Introduction by Charles McCorquordale. Essays by Francis Russell, Edgar Peters
and Catherine Whistler.
200 pages, 31 colour plates, 88 black and white illustrations.
£15 or $23 inc. p. & p.

‡ 1987 *François Boucher and his Circle and Influence.*
Introduction by Regina Shoolman Slatkin.
136 pages, 18 colour plates, 80 black and white illustrations (out of print).

1989 *A Selection of French Paintings 1700–1840 Offered for Sale.*
An exhibition on behalf of Médecins Sans Frontières.
154 pages, 42 colour plates, 77 black and white illustrations. £10 or $15 inc. p. & p.

¶ 1991 *Louis-Léopold Boilly's 'L'Entreé du Jardin Turc'.*
'Spectacle and Display in Boilly's "L'Entreé du Jardin Turc"'. Essay by Susan
L. Siegfried. 36 pages, 25 plates. £10 or $15 inc. p. & p.

¶ 1991 *Eighty Years of French Painting from Louis XVI to the Second Republic 1775–1855.*
70 pages, 20 colour plates. £12 or $17 inc. p. & p.

1991 *Pre-Raphaelite Sculpture. Nature and Imagination in British Sculpture 1 1848–1914.*
An exhibition organized by Joanna Barnes in association with The Henry Moore
Foundation. Hardback book to accompany the exhibition with 174 pages fully illustrated.

¶ 1993 *Fifty Paintings 1535–1825.*
To celebrate ten years of collaboration between The Matthiesen Gallery, London,
and Stair Sainty Matthiesen, New York.
216 pages, 50 colour plates, numerous black and white text illustrations.
£20 or $32 inc. p. & p.

¶ 1996 *Paintings 1600–1912.*
144 pages, 26 colour plates. £12 or $20 inc. p. & p.

¶ 1996 *Romance and Chivalry: History and Literature reflected
in Early Nineteenth Century French Painting.*
Introduction (40 pages) by Guy Stair Sainty, twelve essays, catalogue,
appendix of salons 801–1824 and bibliography.
Hardback book, 300 pages, fully illustrated with 90 colour plates and 100 black
and white illustrations. £50 or $80 inc. p. & p. (scarce).

1996 *Gold Backs 1250–1480.*
An exhibition held on behalf of The Arthritis and Rheumatism Council.
Foreword and four essays. Limited edition hardback catalogue of the exhibition
held in London and New York.
154 pages, fully illustrated with 37 colour plates and 54 black
and white text illustrations. £40 or $65 inc. p. & p. (scarce).

1997 *An Eye on Nature: Spanish Still Life Painting from Sanchez Cotan to Goya*.
Foreword by Patrick Matthiesen. Catalogue entries by Dr William B. Jordan.
Hard and softback catalogue of the exhibition held in New York.
153 pages, fully illustrated with 23 colour plates and 65 black and white text
illustrations. £30 or $50 inc. p. & p. (scarce).

1999 *Collectanea 1700–1800*.
Hardback catalogue of the exhibition held in London and New York.
220 pages, fully illustrated with 46 colour plates. £30 or $50 inc. p. & p.

¶ 1999 *An Eye on Nature II: The Gallic Prospect*.
French Landscape Painting 1785–1900.
Foreword by Patrick Matthiesen and Guy Stair Sainty. Hardback catalogue of the
exhibition held in New York.
195 pages, fully illustrated with 37 full colour plates and 65 black and white illustrations
(many full page). £35 or $50 inc. p. & p.

2000 *Marzio Tamer: Recent Paintings*.
Exhibition held on behalf of *The World Wildlife Fund*.
Softback catalogue, 64 pages, 61 illustrations. £10 or $15 inc. p. & p.

¶ 2001 *European Paintings – From 1600–1917*.
Baroque, Rococo, Romanticism, Realism, Futurism.
Spring softback catalogue, 110 pages, 29 colour plates, 26 black and white illustrations.
£15 or $25 inc. p. & p.

2001 *2001: An Art Odyssey 1500–1720*.
Preface by Errico di Lorenzo and Patrick Matthiesen. 'El Bosque de Los Nino'
by Patrick Matthiesen. Foreword, reminiscences and detailed inventory records
of the Costa seventeenth-century archives by Patrick Matthiesen.
Hardbound millennium catalogue with special binding, 360 pages, 58 colour plates,
184 black and white illustrations. £35 or $60 plus p. & p.

2002 *Andrea Del Sarto Rediscovered*.
Essay by Beverly Louise Brown.
Hardback catalogue, 60 pages, 9 colour plates, 18 black and white illustrations.
Limited edition. £15 or $25 inc. p. & p.

2002 *Gaspar Van Wittel and Il Porto di Ripetta*.
Essay by Laura Laureati.
Hardback catalogue, 52 pages, 2 colour plates, 23 black and white illustrations.
Limited edition. £15 or $25 inc. p. & p.

2003 *Chardin's 'Têtes d' Études au Pastel'.*
Essay by Philip Conisbee.
Hardback catalogue, 33 pages, 2 colour plates, 12 black and white illustrations.
Limited edition. £15 or $25 inc. p. & p.

2004 *Bertin's Ideal Landscapes.*
Essay by Chiara Stefani.
Hardback catalogue, 46 pages, 2 colour plates, 27 black and white illustrations.
Limited edition. £15 or $25 inc. p. & p.

2004 *Polidoro da Caravaggio: Polidoro and La Lignamine's Messina Lamentation.*
Text by P. L. Leone De Castris.
Hardback catalogue, 62 pages, 11 colour plates, 15 black and white illustrations.
Limited edition. £15 or $25 inc. p. & p.

2004 *Virtuous Virgins, Classical Heroines, Romantic Passion and the Art of Suicide.*
Text by Beverly L. Brown.
Hardback catalogue, 60 pages, 2 colour plates, 21 black and white illustrations.
Limited edition. £15 or $25 inc. p. & p.

2007 *Manet, Berthe Morisot.*
Text by Charles Stuckey
Hardback catalogue, 32 pages, 11 colour plates. Limited edition.
£15 or $25 inc. p. & p.

2007 *Jacobello Del Fiore: His Oeuvre and a Sumptuous Crucifixion.*
Text by Daniele Benati.
Hardback catalogue, 80 pages, 12 colour plates, 15 black and white illustrations.
Limited edition. £15 or $25 inc. p. & p.

2008 *Jacques Blanchard: Myth and Allegory.*
Text by Christopher Wright and Andrea Gates.
Hardback catalogue, 5 colour plates, 6 black and white illustrations. Limited edition.
£15 or $25 inc. p. & p.

2009 *A Florentine Four Seasons.*
Text by Andrea Gates.
Hardback catalogue, 96 pages, 11 colour plates, 21 black and white illustrations.
Limited edition. £15or $25 inc. p. & p.

2009 *Théodore Rousseau. A Magnificent Obsession: La Ferme dans les Landes*.
 Text by Simon Kelly and Andrea Gates.
 Softback catalogue, 52 pages, 3 colour plates, 16 black and white illustrations.
 Limited edition. £15 or $25 inc. p. & p.

2009 *The Mystery of Faith: An Eye on Spanish Sculpture 1550 - 1750*.
 Various texts.
 Hardback silk blocked and bound. 300 pages. 112 colour plates, 153 black and white
 illustrations.
 £90 or Euros 100 plus post and packing (charge varies according to destination).

2010 *Révolution • République • Empire • Restauration*.
 Hardback catalogue, 84 pages, 11 colour plates, 39 black and white illustrations.
 £15 or $25 inc. p. & p.

2011 *James Ward: A Lioness with a Heron*.
 Text by Andrea Gates.
 Hardback catalogue, 48 pages, 3 colour plates, 14 black and white illustrations.
 £15 or $25 inc. p. & p.

2012 *Liberation & Deliverance - Luca Giordano's Liberation of St. Peter*.
 Texts by Helen Langdon and Giuseppe Scavizzi.
 Hardback catalogue, 60 pages, 7 colour plates, 21 colour and black
 and white illustrations. £15 or $25 inc. p. & p.

2012 *Joseph Wright of Derby: Virgil's Tomb & The Grand Tour*
 Texts by Jenny Uglow and Bart Thurber.
 Hardback catalogue, 76 pages, 5 colour plates and 74 black and white illustrations.
 £15 or $25 inc. p. & p.

2013 *A Winning End-game: Francis Cotes, William Earle Welby and His Wife Penelope*
 Text by Jenny Uglow.
 Hardback catalogue, 48 pages, 6 colour plates and 17 black and white illustrations.
 £15 or $25 inc. p. & p.

2013 *Vision & Ecstasy: Giovanni Benedetto Castiglione's St. Francis*.
 Texts by Helen Langdon and Jonathan Bober.
 Hardback catalogue, 84 pages, 20 colour plates and 47 black and white illustrations.
 £15 or $25 inc. p. & p.

NOTES

MATTHIESEN

EXPERTS, AGENTS, APPRAISERS AND DEALERS IN
EUROPEAN PAINTINGS
FROM THE FOURTEENTH TO THE NINETEENTH CENTURIES

This catalogue was issued as a limited edition of 650 copies. It was printed in Turin and bound in Milan, Italy, using Garda Gloss 200 gsm soft fine art paper and Komori Lithone S 29 presses in five colours. Illustrations were printed in dry proof quadratone.

The typeface used in the body of the text is based on the Gill Family using his Perpetua font designed by Eric Gill between 1925 and 1929 for Stanley Morrison, the typographical advisor to Monotype. Titles are set in Gill Facia Pro Titling Regular and Perpetua Italic Oldstyle Figures. Title page and half title set in Gill Facia MT Std Italic.

The book is bound using gold blocked Skivertex Sanigal SXS5295. The boards are gold blocked in Gill Golden Cockrell Titling on the recto and Trajan on the verso.

Photographic credits: Comparatives courtesy of The Warburg Institute, London; The British Library, London; British Museum, London; J. Paul Getty Museum, Los Angeles; Bibliothèque Nationale, Paris; Rouen Bibliothèque municipale.

The catalogue text was written by BEVERLY BROWN.

Graphic layout and editing by PATRICK MATTHIESEN.

Colour origination by *Fotomec Srl.* and production by *Tipo Stampa*, Turin.

This catalogue was designed by PATRICK MATTHIESEN.
The essay *Fatal Attraction* is © MATTHIESEN LTD and BEVERLY BROWN.
Copyright Reserved March MMXIV by MATTHIESEN LTD., LONDON.

ISBN 978-0-9575459-1-5